T0322814

SKEGNESS

PAST & PRESENT

WINSTON KIME & KEN WILKINSON

The History Press

*Fifty per cent of the royalties from this book will be donated
to the late Winston Kime's charity, the Skegness Lifeboat.*

First published 2012
Reprinted, 2019

The History Press
97 St George's Place, Cheltenham,
Gloucestershire, GL50 3QB
www.thehistorypress.co.uk

British Library Cataloguing in Publication Data.
A catalogue record for this book is available from the British Library.

isbn 978 0 7524 6012 3

Typesetting and origination by The History Press
Printed in Great Britain by TJ International Ltd, Padstow, Cornwall.

CONTENTS

ACKNOWLEDGEMENTS

Thanks go to the following for all their help:

Lincolnshire Library; staff of the Skegness Library; Skegness U3A (Third Age Trust) Local History Group; Jim and Jennifer Mackley, for help with the final formatting of text; the family of the late Winston Kime, for the loan of archive material; Sarah Wilkinson, for initial proof reading; and William Richards, for his assistance.

BIBLIOGRAPHY

Kime, Winston, *SKEGGY! The Story of an East Coast Town*, Seashell Books, 1969
Kime, Winston, *The Book of Skegness*, 1986
Kime, Winston, *The Skegness Date Book 1850-2000*, 2006
Loveday, Jack A., *Square-Bashing by the Sea: RAF Skegness 1941-1944*, 2003
Wilkinson, Marjorie C., *Skegness at War*, 2007

FOREWORD
BY DAVID KIME

My father, Winston Kime, was born in Skegness and spent over ninety years of his life in the town, working for Skegness Council from the age of fourteen (when he left school) until his retirement in 1972. He witnessed first-hand the transformation of Skegness from a small village into a major seaside resort, and acquired at the same time an encyclopaedic knowledge of the town and its inhabitants. In 1969, he published his first book *Skeggy! The Story of an East Coast Town*, which was followed by a further fifteen publications over the subsequent forty years, all illustrated by pictures from his extensive collection of postcards and old photographs – an archive which he left for use by local historians. In recognition of his services as the town historian he was made an Honoured Citizen of Skegness in 2001.

In 2010, The History Press asked him to write *Skegness Past & Present*; although they had little idea that he was already ninety-eight years of age. He started the project with his usual enthusiasm, and, although mobility was an increasing problem, he toured the town on his electric scooter seeking out the 'new' photos. Sadly, a number of falls during the year resulted in his death in November 2010, with the book still uncompleted. I am delighted that Ken Wilkinson has agreed to complete the book, which will be published in what would have been my father's 100th birthday year. In March 2011, Winston's ashes were scattered at sea, close to the town in which he grew up and loved so dearly.

Winston Kime at his home in Skegness in 1998. (Courtesy of Ben Hardaker)

INTRODUCTION

The story of Skegness, since it became a bathing place some 200 years ago, can be divided into three phases. In the late eighteenth century it was a small farming village, beginning to attain a little local fame for its bathing beach. So it continued until just before 1880, when the ninth Earl of Scarbrough decided to develop it as a fully-fledged seaside resort. The third phase started around 1920, when the Urban District Council, having acquired the seashore, set about the task of raising Skegness to the forefront of east coast holiday towns.

In the year 1801, when the first official census was taken in this country, there were only twenty-three houses in Skegness and the population was 134. Winthorpe was then a separate parish and contained forty houses and 221 people. Twenty years later the Skegness population had increased by only sixteen to 150 and Winthorpe had risen to 283, making a total population of 433 for the two parishes.

It was not really a seaside resort, but there were visitors here. They had apartments at some of the cottages in the High Street, while the wealthier ones stayed at either the Vine or Hildred's Hotel.

The second phase began when Mr Vivian Tippet, the ninth Earl of Scarbrough's estate agent, suggested to the Earl that he transform his little farming and bathing village into a seaside resort. As Mr Tippet stood on the wide beach and inhaled the salty air, its possibilities suddenly became apparent. In imagination he pictured a beautiful town of wide, tree-lined streets, leading down to the golden sands. Vivian Tippet, with the Earl's blessing, enlisted the aid of Gilbert Dashper, clerk of the Local Board, and John Whitton, a Lincoln architect. Together, they drew up a grand plan for the creation of a new seaside town.

The plan shows a rectangle contained between Grand Parade, Lumley Road, Roman Bank, and what is now Castleton Boulevard. The first phase of the development was restricted to the area between Lumley Road and Scarbrough Avenue. Castleton Boulevard was not made until 1934, but was shown on an earlier plan as Osbert Road. The promenade (Grand Parade and South Parade) constructed on the sea wall opened in 1879.

The Boston to Grimsby railway line came into being in 1848. The branch line from Firsby to Wainfleet was opened in 1871, but the five-mile extension from Wainfleet to Skegness was not opened until 28 July 1873. On August Bank Holiday 1882, the railway brought 22,000 day-trippers to Skegness, 20,000 of whom paid to go on the pier, which had just opened. It was regarded as one of the marvels of the age. Never before had so many people crammed into the town. All food shops were cleared of stock and by six o'clock in the evening, when the trains began to leave, nearly 20,000 people tried to squeeze into the station. The last train did not get off until half past two in the morning!

The third phase came after the Skegness Urban District Council purchased the seashore from the Earl of Scarbrough, for a modest £15,000. The surveyor, Rowland Henry Jenkins, returned to Skegness after serving as a Captain in the Royal Engineers during the war; he presented his plan just before Christmas 1921, and got down to the business of providing the resort with a boating lake, bathing pool, waterway, paddling pool, putting greens, bowling greens, tennis courts, refreshment rooms, public shelters, formal gardens and other amenities. The old sand pullover (a gap in the dunes where the boats were pulled through) from the Clock Tower to the beach was replaced by an asphalt road and footway, which became known as 'Jenkin's Pier'. Rowland Jenkin's served the Council for forty years between 1912 and 1952.

Billy Butlin arrived in Skegness in the early 1920s. Up to that time he had travelled the fairgrounds. He began in a very modest way with a few hoopla stalls, clearing a space in the Jungle, on a site now occupied by the County Hotel. (The Jungle, as it was known, was a strip of wild woodland mixed with gorse, with a bank of dunes on the east side that extended, at that time, from Scarbrough Avenue to Sea view Road.) He then set up the big central amusement park near the pier. Skegness was good for him and he was good for Skegness.

After a few years the great showman built his first holiday camp, just north of Skegness, which was opened in 1936.

The Royal Navy took over Butlin's Camp at the outset of the Second World War; it became the training ship HMS *Royal Arthur*. Lord Haw-Haw, the German propagandist, broadcast that it had been sunk. The camp was flooded during the great floods of 1953, along with much of the rest of the Lincolnshire coast, from Mablethorpe down to the Wash. Much diversification took place during the ensuing years when former agricultural land became the home of thousands of caravans. Local entrepreneur John Woodward set up as a caravan manufacturer in Ingoldmells, and later established the popular Fantasy Island Theme Park.

Today, Skegness is a very pleasant resort with the Clock Tower still its main feature. In the nearby Compass Gardens, the Jolly Fisherman statue sits on top of the central fountain, overlooking a blaze of colour from the well planted flower beds, a credit to the 'Parks and Gardens' team.

The refurbished Tower Gardens have retained the pond feature; children love the new playground, while parents sit nearby, perhaps listening to the Sunday afternoon band concerts.

Natureland is also a big attraction, enjoyed by all ages. Opened in 1965, it is noted for saving the lives of grey and common seal pups washed up on our coast.

The Embassy Theatre provides excellent entertainment throughout the year; it also houses the town's Information Centre. The town also has a small but pleasant shopping precinct on the site of the former Hildred's Hotel.

In this book, remember that the 'present' image of today could be a 'past' image as early as tomorrow.

Ken Wilkinson, 2012

1

THE TOWN:
LUMLEY ROAD
AND HIGH STREET

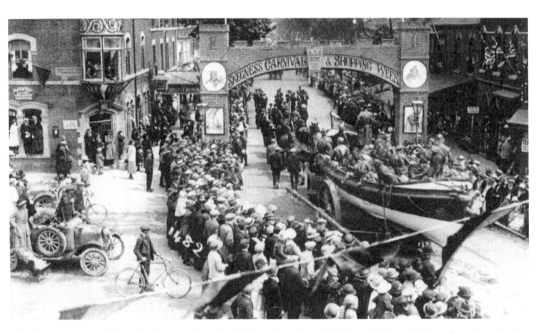

The Skegness annual carnival procession, headed by a band and the town's lifeboat, *Samuel Lewis*, entering Lumley Road under a mock medieval archway in 1921. The crew are dressed in oilskins and lifejackets. Note that almost all of the spectators wear some sort of headgear.

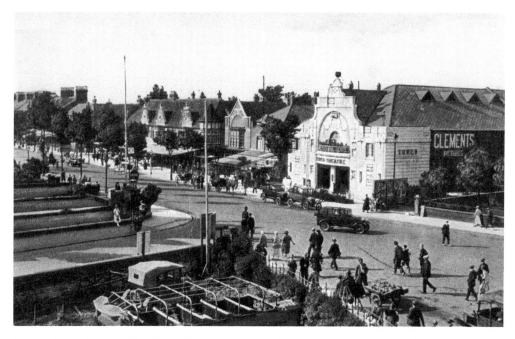

Lumley Road, Skegness. The Tower Theatre was opened by Fred Clements on 25 July 1921. Although showing films from their inception, early cinemas were frequently known as theatres. Wartime bombing closed the Tower Cinema until 1951, when it was almost entirely rebuilt. The bombing occurred at 4 p.m. on Saturday, 18 January 1941, during a children's matinee, but miraculously there were no fatalities.

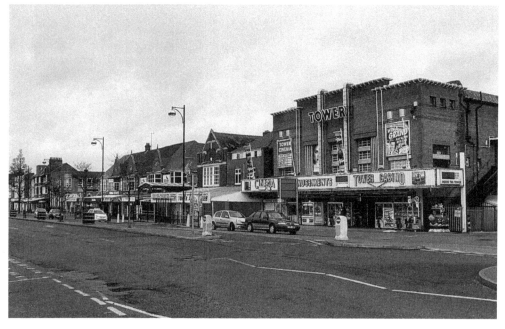

The Tower Cinema and Amusement Arcade. Further structural alterations took place after the business changed hands in 1978. Today, the cinema has two screens on the first floor, with the amusements on the ground level. (Photo by Ken Wilkinson)

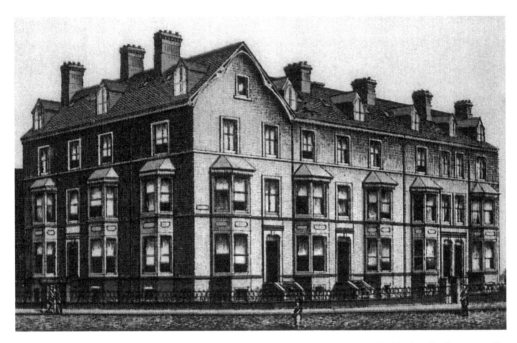

Gomershall Terrace. Shown in this 1880s' lithograph was the most easterly block, which eventually formed a continuous row with Harrington Gardens and Lumley Terrace, stretching as far as what is now Beresford Avenue. This corner building became the Marine Hotel after it was converted by W.B. Lambe soon after the end of the First World War.

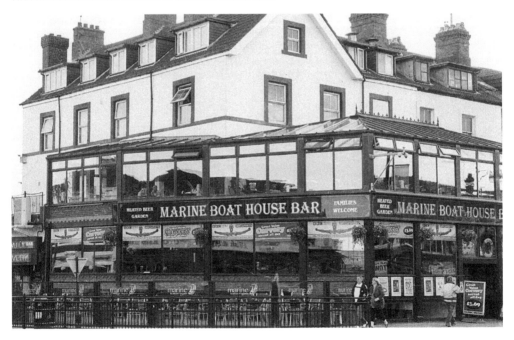

The Marine Boathouse Bar. This modern structure, which extends to the edge of both Lumley Road and Drummond Road, is a very popular venue in full view of the Clock Tower and Marine Gardens. (Photo by Ken Wilkinson)

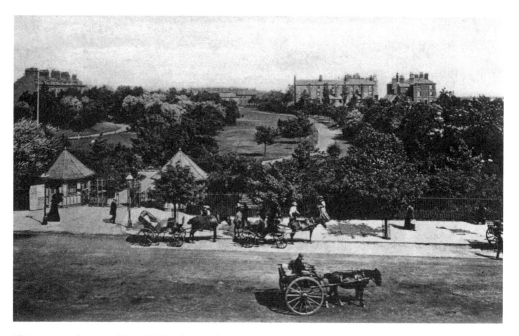

This postcard, posted in 1907, shows the entrance to the Pleasure Gardens on Lumley Road. St Matthew's Church can just be seen in the distance on the left, along with Rutland Terrace. The block in the far centre right is Edinburgh Avenue. During the early 1800s, colliers from Tyneside landed several thousand tons of coal on Skegness beach every year; it was carted to this area, which was a coal yard, as shown on an 1849 map of Skegness by S. Hill & Sons of Croft.

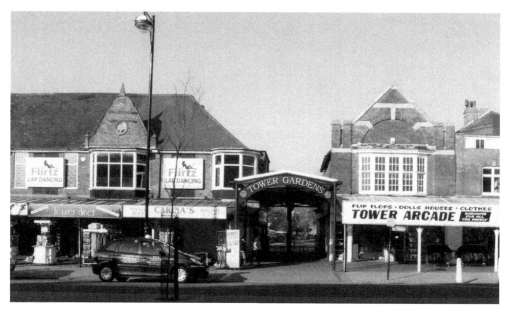

This is the same entrance to the Pleasure Gardens, now known as the Tower Gardens. The row of shops to the left of the entrance were built in 1924. The largest occupiers were Lowndes Arcade on the corner of Rutland Road, a family business that is still trading today. Other occupiers of this block were Mrs Watson's Tower Café and dance hall, and Smith's toy arcade. (Photo by Ken Wilkinson)

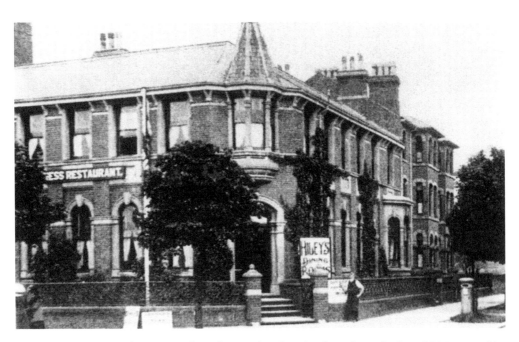

Hiley's Restaurant on the corner of Lumley Road and Rutland Road was built in 1881 as a public reading room and library; possibly largely owing to illiteracy it was forced to close. It later became Hiley's Restaurant, noted for their one shilling hot dinners.

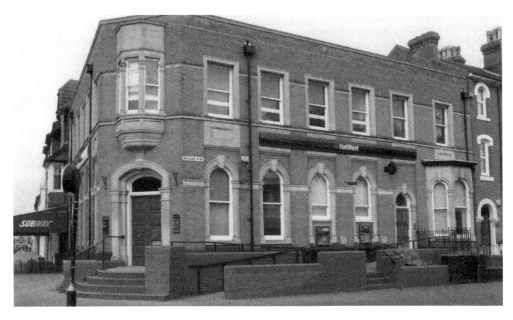

Hiley's Restaurant was converted to the National and Provincial Bank in the twentieth century, later to become a branch of the National Westminster Bank. (Photo by Ken Wilkinson)

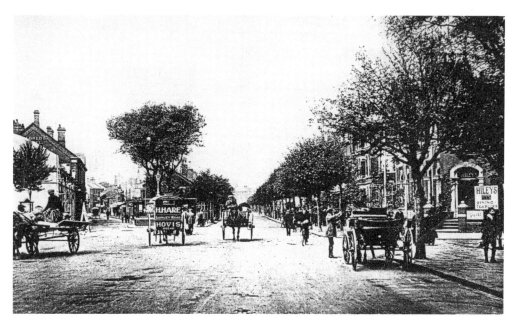

Lumley Road looking west, with the High Street branching off to the left, *c.* 1900. Hildred's Hotel is prominent, built as the New Hotel in the early nineteenth century. It was advertised in the *Stamford Mercury* on 14 May 1813 'as being close to the shore with seawater baths and bathing machines'. Joseph Hildred took over in 1828, but died twenty years later. His wife, Sarah, carried on and renamed the hotel. Hiley's Restaurant is on the right.

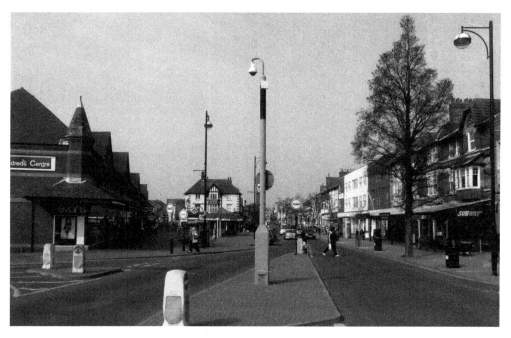

A similar view today. Hildred's shopping centre was officially opened by celebrity magician Paul Daniels on 17 September 1988. The Subway fast-food establishment, seen on the right, has recently taken over from Blackbourne's shoe shop after over ninety years of trading. (Photo by Ken Wilkinson)

Demolition of the underground lavatories in Lumley Road in 2001 in front of Hildred's shopping centre; they had been in existence for over a century. New toilet facilities in nearby Briar Way have taken their place. (Photo by the late Winston Kime)

A light refreshment kiosk now operates where the underground lavatories once stood. (Photo by the late Winston Kime)

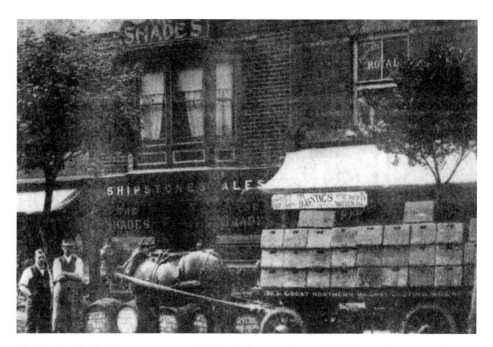

The Shades Hotel. The tenancy was held by G. Severn prior to 1913, it was later passed on to Harry and Sarah Selby. In 1935, the roof was jacked up to accommodate an upstairs lounge, refurbished again in 1986 and extended through to the High Street. This 1920s photograph shows a delivery of crates on a railway dray, collecting empty barrels; landlord Harry Selby is on the far left.

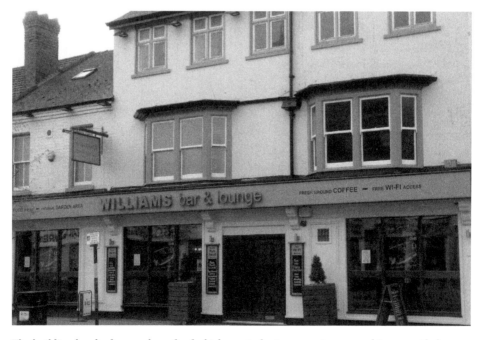

The building has had a number of refurbishments during recent years and is currently known as Williams Bar and Lounge. (Photo by Ken Wilkinson)

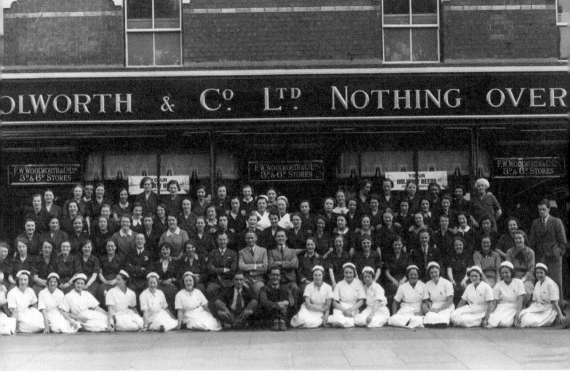

The staff of Woolworth & Co. Ltd soon after the store opened in 1928. Note the cafeteria ladies sitting on the ground in the front row. The branch closed down on 6 January 2009, when the giant retailer went into liquidation.

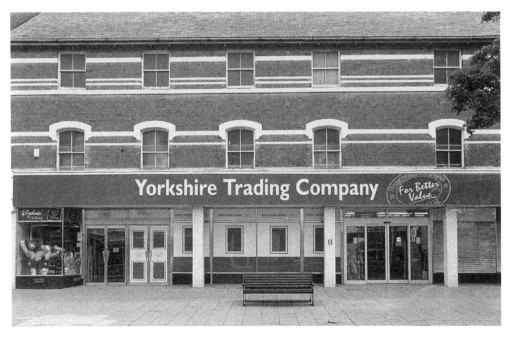

The Woolworth shop was reoccupied almost immediately by a branch of the Yorkshire Trading Company, selling a variety of articles almost identical to 'Woolies'. (Photo by Ken Wilkinson)

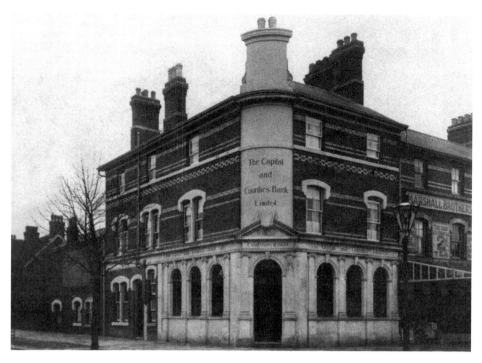

The Capital and Counties Bank was established here from 1911. Prior to that they were in the Earl of Scarbrough's estate offices on Roman Bank, which later became Skegness Council offices. Next-door neighbours in Lumley Road were grocers Marshall Bros, which later became the International Stores.

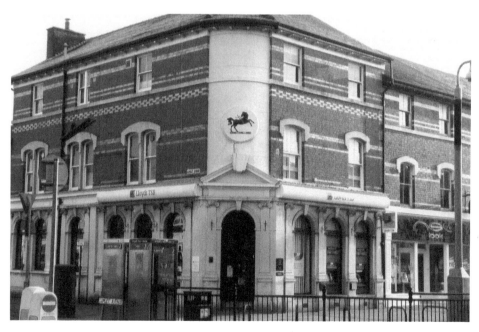

The building is now Lloyds TSB. The building on the right is currently a New Look clothing store. (Photo by Ken Wilkinson)

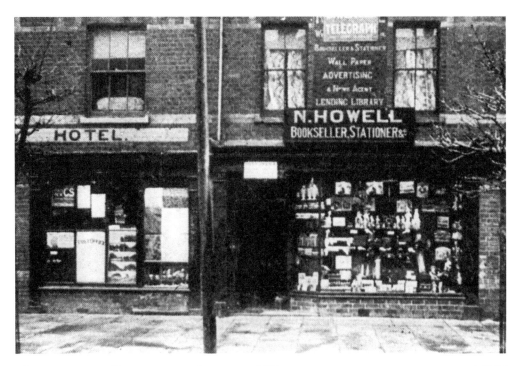

Above Nester Howell's newspaper and stationery shop in Lumley Road also served as the Skegness General Post Office from 1878, but in 1905 the post office moved to separate premises on the corner of Roman Bank and Algitha Road, which is now a second branch of Lloyds TSB. The Lincoln Hotel to the left of the photograph is long gone.

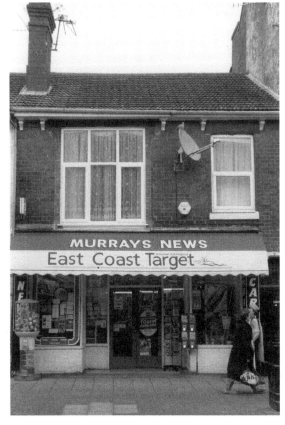

Right The newspaper shop traded as Avery's for many years, but is now Murrays News. *East Coast Target* is a local newspaper. (Photo by Ken Wilkinson)

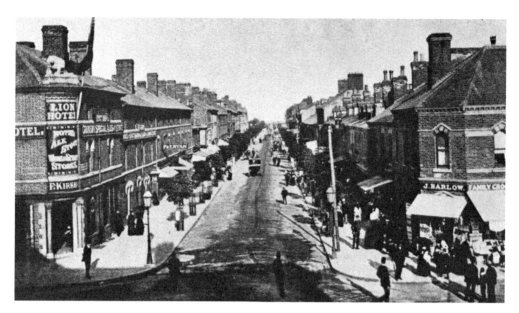

This photograph of Lumley Road, taken in the early 1890s, clearly shows the stone lion carved by Richard Winn of Grimsby, on the roof of the Lion Hotel, which was built in 1881; Samuel Clarke was the first landlord. The sign F. & T. Ryan belonged to a butchers shop. On the right, James Barlow was the main family grocer and provision merchant in the town; the shop was noted for its aroma of freshly ground coffee. The shop next door was Rowley's Ironmonger.

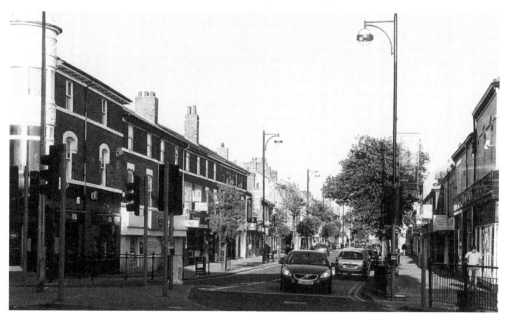

The Red Lion. Renamed after Wetherspoons took over, the former saloon bar of the hotel is now occupied by bookmaker William Hill; prior to this it had been used as a charity shop for Imperial Cancer Research. The Argos catalogue store, opened in 1996, occupies the former restaurant area of the hotel on the Lumley Road frontage; this had been used for shops since 1983. Charity shops have replaced many of the former family-run establishments in Lumley Road. (Photo by Ken Wilkinson)

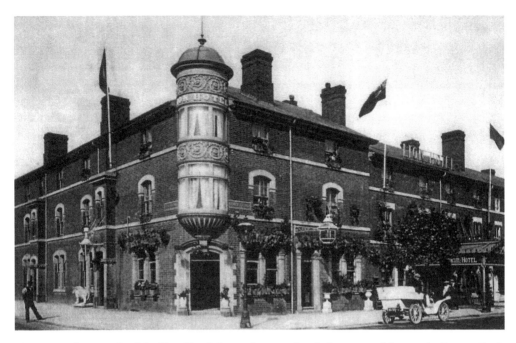

This 1906 photograph of the Lion Hotel shows the stone lion in its new position on the Roman Bank frontage; it was taken down from the roof for safety reasons in 1904. This then became an attraction for children of all ages to sit on.

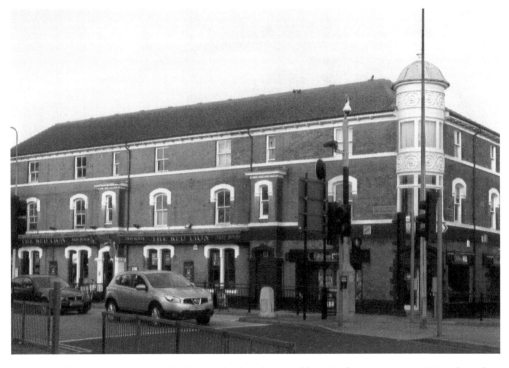

The stone lion disappeared shortly before the hotel was sold to Wetherspoons in 1996, when they changed the name to The Red Lion. (Photo by Ken Wilkinson)

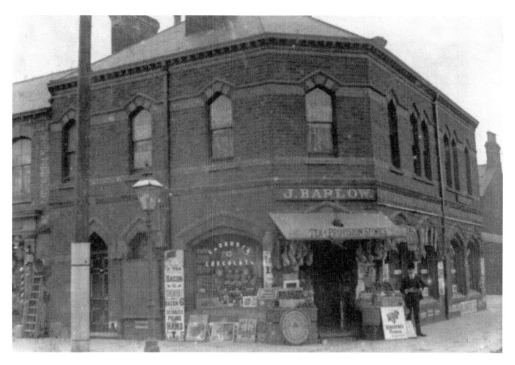

James Barlow established his family grocery business in the early 1890s. It was sold in the 1920s to Keightley's, the Boston clothing and drapery store.

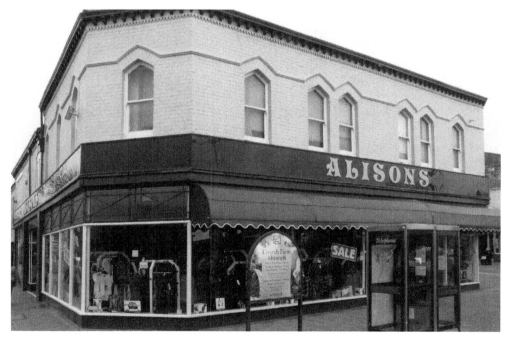

Keightley's of Boston ran this store until it was taken over by Harco, the town's first supermarket, in 1970. It returned back to a clothing store in 1978 when the present owners, Alisons, took possession. (Photo by Ken Wilkinson)

View of the High Street, looking west, showing Hildred's Hotel and shops. Prior to the First World War, the brewery 'Bass' built the Lawn Theatre, seen in the foreground; it was leased to Fred Clements in 1911. After the war, Fred Clements built the Tower Cinema. The Lawn Theatre was re-let to Henri DeMond in 1921. He used it as a cinema until its closure in 1934. It was then that the building was incorporated into the hotel, with the lock-up shops on the street frontage. This photograph was taken on 12 March 1987, just prior to the demolition of the entire block. The underground toilets on the right were demolished in 2001. (Photo by the late Winston Kime)

The scene today, with Hildred's shopping centre replacing the hotel. The centre provides a variety of quality shops and has been a major improvement to the town. (Photo by Ken Wilkinson)

GEORGE MORLEY,

Member of the Pharmaceutical Society of Gt. Britain,

Chemist and Druggist,

50, LUMLEY ROAD,

The Oldest Established (1874) Chemist's Business in Skegness.

Physicians' Prescriptions carefully dispensed with the best drugs and purest chemicals.

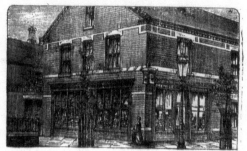

STATIONERY AND FANCY DEPOT.

Wools, Needle Worked Views, and varied assortment of Fancy Goods.

CIRCULATING LIBRARY.

DAILY & WEEKLY NEWSPAPERS. PERIODICALS.

N.B.—Attendance is given on Sundays at private residence, Fountain Villa opposite, for dispensing Medicines.

Agent for the Money Order Bank, Limited.

AERATED WATERS.

Left An advert from the earliest Skegness guidebook, compiled by A.E. Jackson in 1883. George Morley started his chemist business in a wooden hut on the High Street in 1874, prior to using this site, which spans both the High Street and Lumley Road at the eastern end. Mr Morley also ran a library, but his speciality was his home-made perfume, 'Skegness Bouquet', which he sold in fancy bottles. After the Second World War this building became Tonglet's bakery and café.

Below The premises today continue as a bakery and café, known as the Hot Roast Company and Farmhouse Bakery. (Photo by Ken Wilkinson)

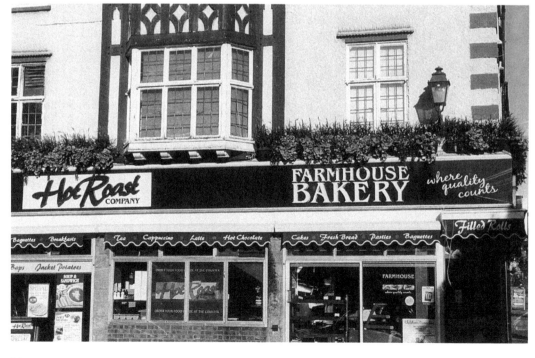

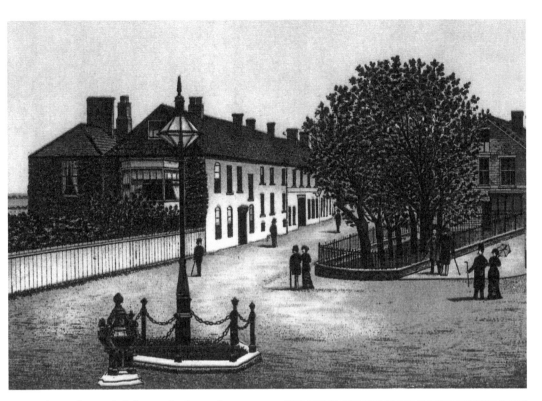

Above This early lithograph shows the junction of Lumley Road and the High Street in the 1880s, before the underground toilets were built in this area. Hildred's Hotel is on the left. Note the small iron drinking fountain near the lamppost.

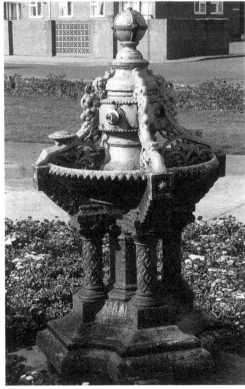

Right The Victorian drinking fountain shown in the photograph above, now no longer in use, can today be found in the centre of a flowerbed, near the entrance to Natureland on North Parade. (Photo by Ken Wilkinson)

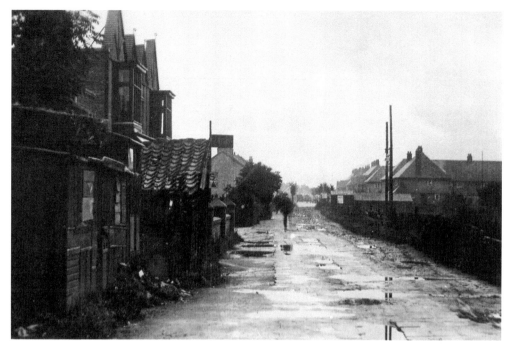

Briar Way, or Oyster Shell Lane as it was known, so named because a local fishermonger used to tip his seashells here, *c.* 1920. The centre sign reads RAOB (Royal Antediluvian Order of Buffaloes). Note the then newly erected houses on Briar Way.

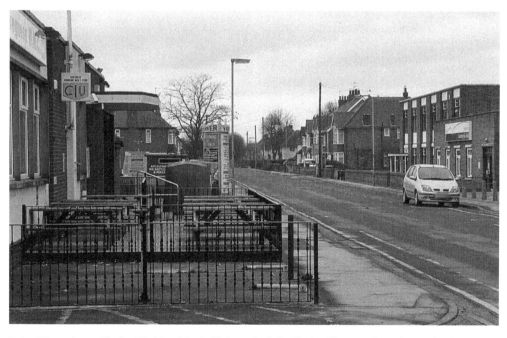

Briar Way today, with the Working Men's Club on the left. The building on the right used to be the Job Centre but is now Skegness Academy, opened in 2006 in conjunction with Boston College. It is part of the Grimsby Institute of Further Education. (Photo by Ken Wilkinson)

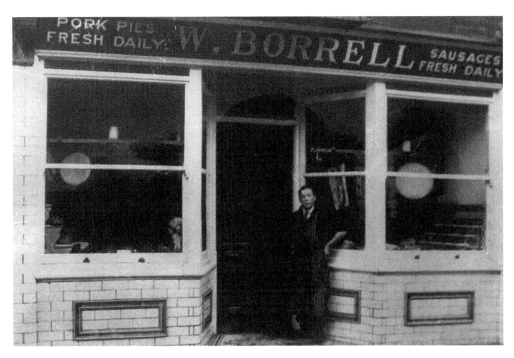

Borrell's original pork butcher was established here in the High Street in 1899. During the Second World War the proprietor was Mr Holland, still trading as Borrell's. The photograph is a copy of one supplied by the present owners, showing Mr Borrell standing in the doorway.

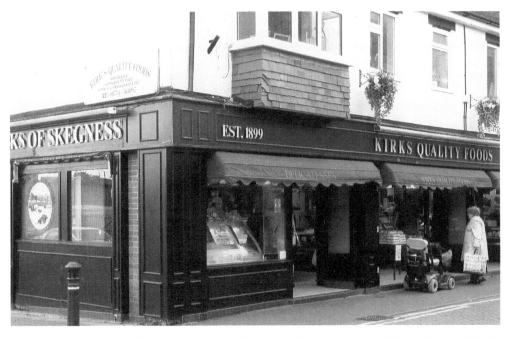

Kirks of Skegness, pork butchers. Dennis Kirk bought the business in 1963 and extended the premises, taking over the shop next door, formerly a clothing store called Limelight. Today the business is managed by brothers Andrew and John Kirk. (Photo by Ken Wilkinson)

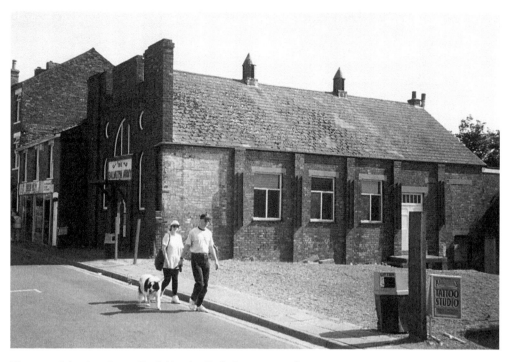

Skegness Salvation Army Citadel in the High Street opened in 1929; it was demolished in December 1994 to make way for a new church. (Photo by the late Winston Kime)

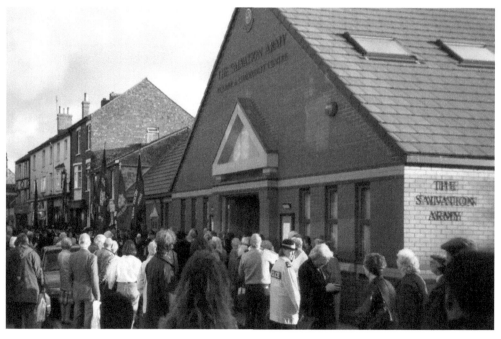

The official opening of the new Skegness Salvation Army Citadel on 4 November 1995. (Photo by the late Winston Kime)

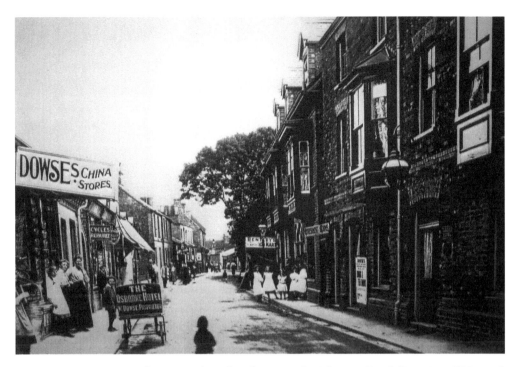

High Street, *c.* 1910. Note the cart on the right advertising the Osbourne Hotel, 'Proprietor W. Dowse', with Dowse's china store opposite.

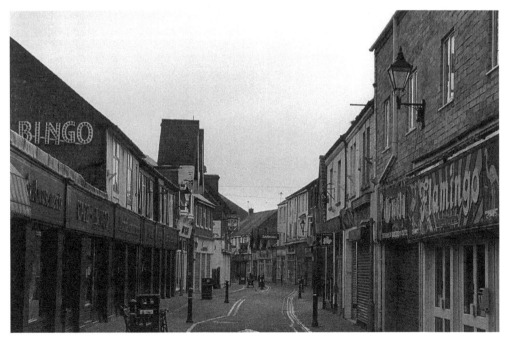

High Street looking east, also known as 'fish and chip alley' to holidaymakers. The street is pedestrianised during the holiday season, while one-way traffic is allowed during the winter months. (Photo by Ken Wilkinson)

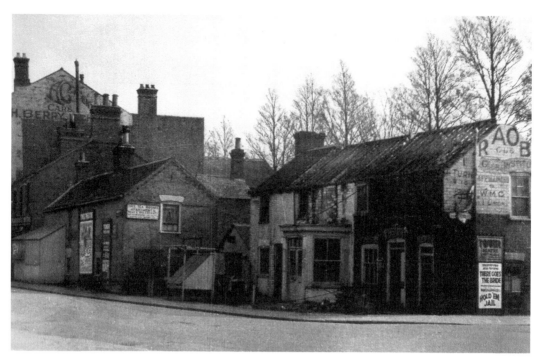

This photograph was taken in 1933 at the Lumley Square end of the High Street. The cottages had just started to be demolished; the Gas showroom was opened on this site one year later.

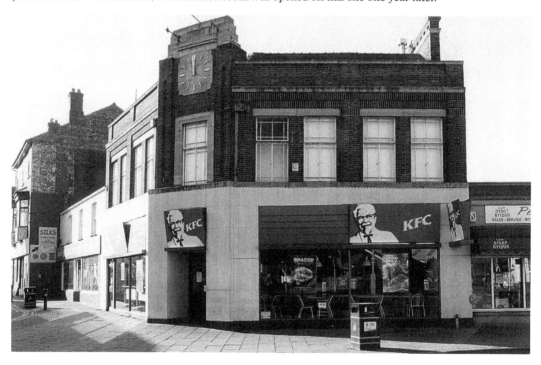

The Kentucky Fried Chicken restaurant (KFC) has been trading here since 1996. (Photo by Ken Wilkinson)

2

THE TOWN:
OTHER STREETS

Rutland Road, looking north. Dating from 1890, the road was built on a sea defence known as Green Bank, which extended from the south, beyond the Vine Hotel, through what is now Coronation Walk, Drummond Road, Rutland Road and Park Avenue, before joining the Roman Bank at the North Shore Road. Rutland Terrace was erected during a national depression. Unable to sell the new houses, the builder, T.L. Kassell, was forced into liquidation. It is interesting to note that although this chapter is titled 'Other Streets', apart from the High Street, there are only two other streets in Skegness: Cross Street off Wainfleet Road, and Prince George Street – which was previously known as Lumley Back Road, before the late C.H. Major (a printer) requested to have it changed, due to his dislike of seeing 'Back Road' on his notepaper. The Council refused but, undeterred, he continued to use the name Prince George Street as his address and, eventually, the Council erected a road sign with that name on it. (Photo by Ken Wilkinson)

Algitha Road, at the junction with Lumley Avenue, is pictured on this postcard franked in 1905. The house on the right was the residence of G.J. Croft, whose drapery store, opened in 1880, was at that time the largest shop in Lumley Road. From his windows, Mr Croft enjoyed the view of customers going in and out of his store just a few hundred yards away. The store was closed in 1983 and later demolished. The new building now contains the Nationwide Building Society, Clinton Cards, and Greggs Bakery.

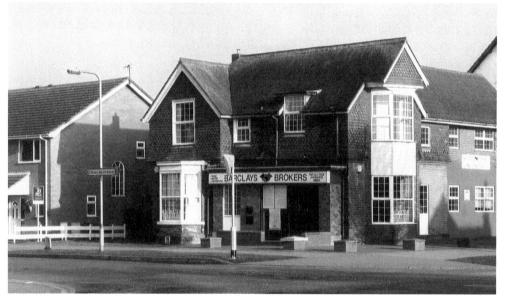

This house became the office of a local newspaper, the *Skegness Standard*, for many years. It is now Barclays Brokers Insurance office. (Photo by Ken Wilkinson)

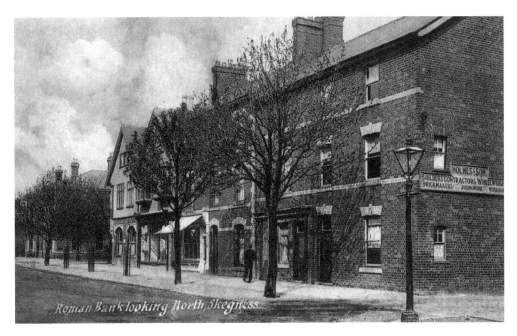

Roman Bank looking north. On the far left behind the trees, at the junction of Algitha Road, was the site of the Council Offices, destroyed by fire in 1928. Across the road, the ground-floor premises with the rounded windows housed the General Post Office, which later moved over the road to purpose-built quarters in 1929, where it remained until relocating to the Co-op Lumley Road store in 1993, and again in 2000 to the Hildred's Centre Co-op food-store.

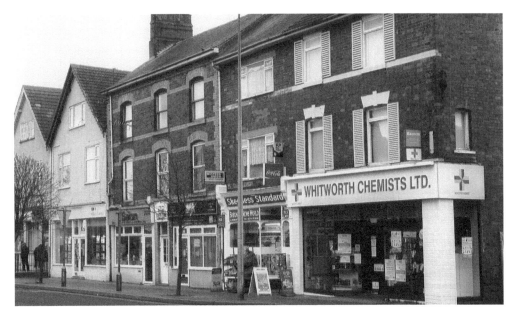

From the right is Whitworth Chemists Ltd, Apex convenience shop, Light-Bites, a unisex hair salon, William Brown Estate Agent and, on the corner of Algitha Road, a branch of Lloyds TSB. (Photo by Ken Wilkinson)

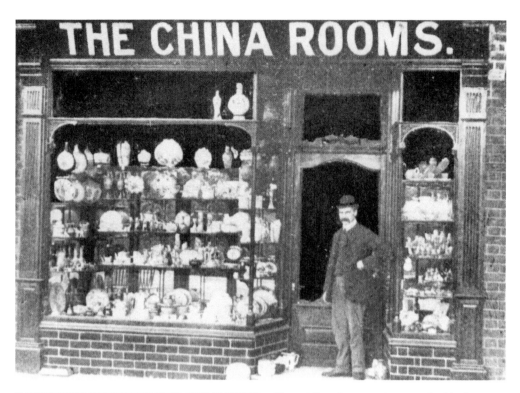

THE CHINA ROOMS.

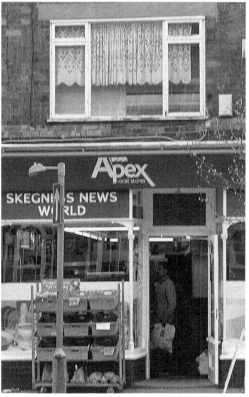

Above Albert Lomax, photographed in front of his china shop at 6 Roman Bank in 1910. In the 1930s Mr Lomax opened a petrol station at Croft Bank, at the junction of the A52 and Croft Low Road, long known as Lomax's Corner. There is still a motor business here today.

Left For many years the shop was a tobacconist's owned by H.B. Smith. The building still retains the same shop front over a century later. Now numbered 14 Roman Bank, it is an Apex local convenience store. (Photo by Ken Wilkinson)

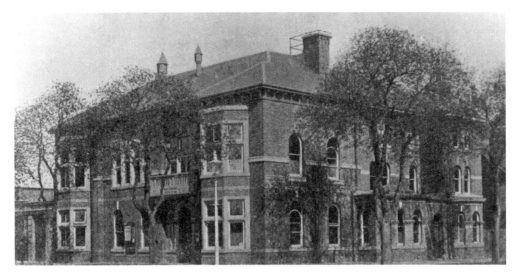

The rebuilt Council Offices in 1930, renamed the Town Hall. The former building on this site, on the corner of Roman Bank and Algitha Road, was destroyed by fire in 1928. After the fire, all salvageable files and papers were taken to a pair of newly built houses in Ida Road, and later sorted, by category, into different rooms in the houses; these became the temporary Council Offices for the next three years. Note the balcony above the main entrance: it was from here that election results were announced. This building was demolished after the Council moved to North Parade in 1964, when they took over the former National Deposit Friendly Society Convalescent Home.

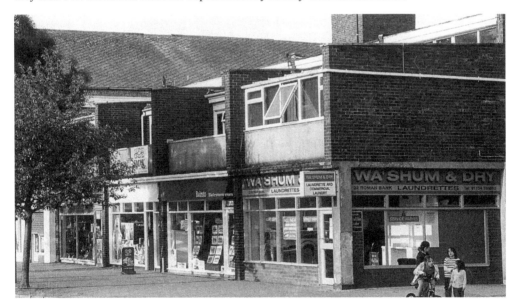

On the site of the old Town Hall is this modern complex of shops and flats. On the corner is a launderette. Next door is Bairstow Eves Estate Agent, then Smack Foods, followed by Seacroft Mobility (a mobility scooter store). In the former fire station, called Vespa House, are two shops, one is a hairdressers called The Barber's Chair and the other is Paul's Tattoo Studio. The fire station moved to new premises on Churchill Avenue in 1973; the old hose-drying tower is still prominent above the roof of the Roman Bank Bingo Hall. (Photo by Ken Wilkinson)

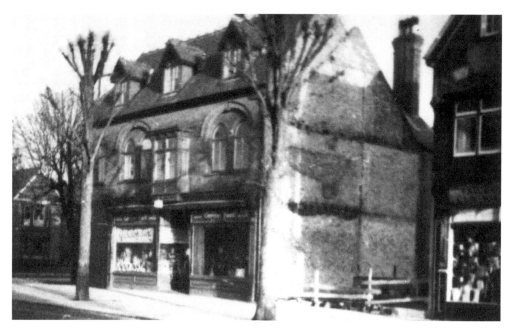

Roman Bank near the Scarbrough Avenue junction in 1946. The building to the left was Gordon Kent's pharmacy and opticians' consulting rooms; it later became Kingham's chemist and drug store. On the right is part of the double-fronted shop of the Chester-based Bradley's gents' clothiers. The vacant gap between the buildings later became Frank Evans' fish and chip shop, before trading as Sparke's fish shop.

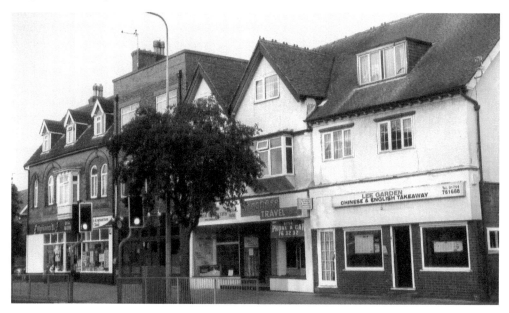

The corner shop is now Workwear 2U; next door is a Chinese acupuncture and herbal clinic. The vacant gap in the above picture is now filled by the San Francisco Bar; to its right we have Skegness Liberal Democrats, Skegness Travel, and Lee Garden Chinese and English take-away. (Photo by Ken Wilkinson)

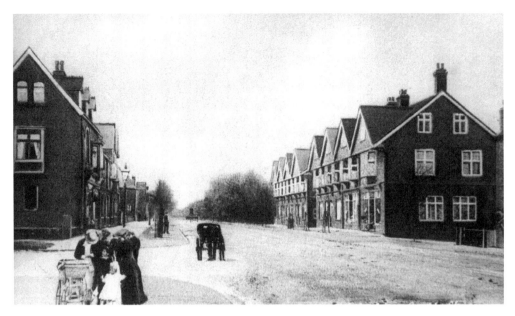

This early twentieth-century photograph of Roman Bank looks south from the junction of Scarbrough Avenue (on the left) and Grosvenor Road (on the right). The corner building on the left became Ralphs and Co. Grocers in 1910. Behind the trees in the centre of the photograph is the old Hall; a nineteenth-century residence, coach-house and stables set in over two acres of land.

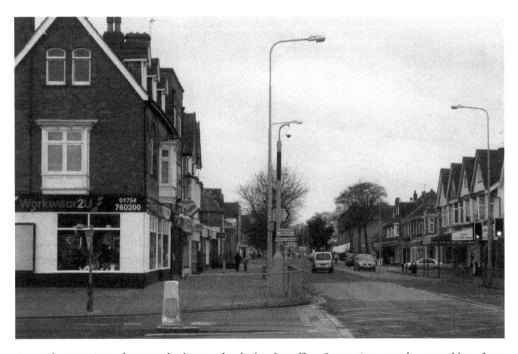

An early morning photograph, hence the lack of traffic. Congestion can be a problem from mid-morning, especially during the holiday season. (Photo by Ken Wilkinson)

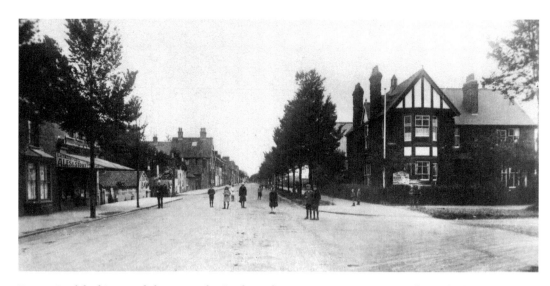

Roman Bank looking north from near the Scarbrough Avenue junction, *c.* 1920. The Derbyshire Poor Children's Home is on the right. The home was established in 1891 to provide a holiday break for disadvantaged children. It all started with Mr H.B. Sykes of Derby, taking a dozen poor children from Derby to stay in a lodging house in the High Street, Skegness, for a week's holiday. When sufficient cash was raised to purchase this building, it was opened as the Derbyshire Poor Children's Home. John Whooley had a sweetshop and grocery store with an off-licence, seen opposite with the awning. Mr Hubbard had a blacksmith's workshop next door, which was later owned by Bill Neal.

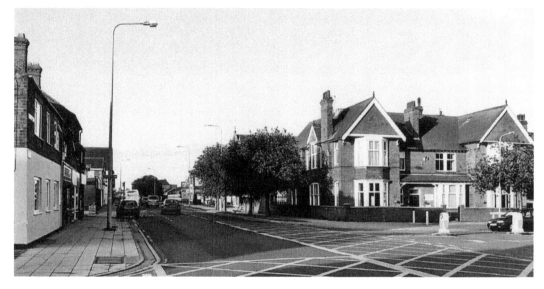

The Derbyshire Children's Holiday Centre, as it is known today, provides 450 children aged between seven and thirteen with a seaside holiday in comfortable accommodation every year; the home had a complete refurbishment at cost of £80,000 and was reopened in April 2006. Two octogenarians, eighty-seven-year-old Ken Hembur and eighty-eight-year-old Mable Baggulay, who had both attended the home in the 1920s, were invited to cut the ribbon to officially reopen the centre. Children now attend the centre from Monday to Friday between the months of April and November, in the care of the centre managers, Mrs K. Briggs and Miss A. Byerley.

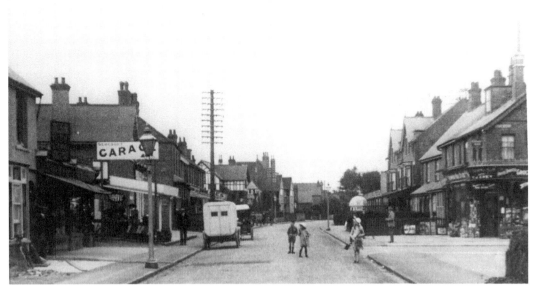

Drummond Road, at the Clifton Road junction in the 1930s. Leonard Brown's long-running grocery and sub-post office is on the corner.

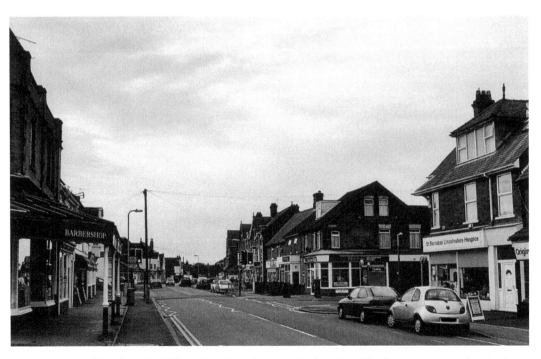

Drummond Road at the Clifton Grove junction, as it looks today. The former grocery shop and post office has recently been a furniture store but is now an empty shop. On the opposite corner is the long established charity shop, St Barnabas Lincolnshire. (Photo by Ken Wilkinson)

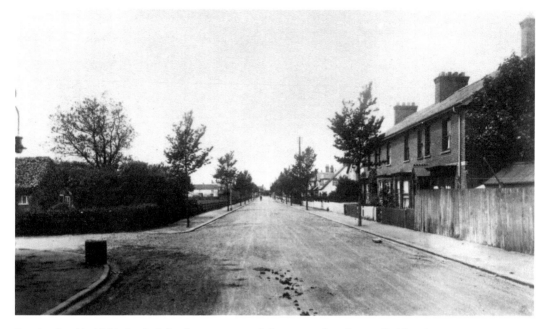

Seaview Road in 1923. On the left is the cow pasture belonging to the white-walled farmhouse on Roman Bank, just visible centre left; this was originally a narrow track known as Sea View Lane, the name it retained for some years after becoming a proper road. The footway to the left became Park Avenue.

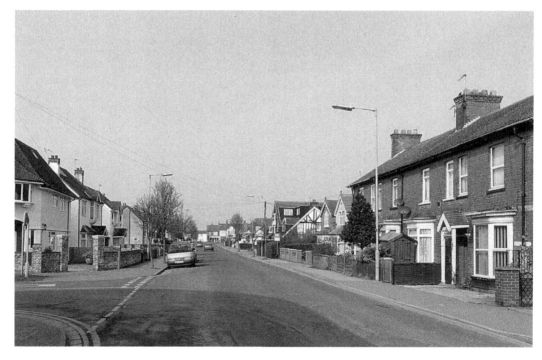

Sea View Road today is now completely built up with residential homes and guesthouses. It is also on the bus route to and from Mablethorpe. (Photo by Ken Wilkinson)

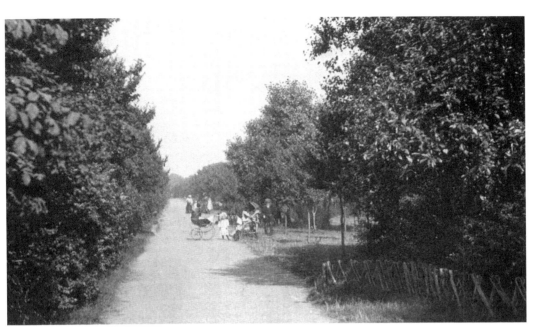

The public footpath through the park or 'Jungle' – this was the name the troops gave to the area whilst camping here during the First World War. This view looks north from Scarbrough Avenue towards Sea View Road in the 1920s. This was later developed into Park Avenue.

Park Avenue was gradually built up from the 1930s, with a number of homes being rebuilt after the Second World War following bomb damage. (Photo by the late Winston Kime)

Skegness Cottage Hospital in 1913. The Earl of Scarbrough donated the site and the foundation stone was laid by HRH Princess Marie Louise of Schleswig-Holstein, granddaughter of Queen Victoria, in 1911. It was opened by the Countess of Scarbrough on 19 May 1913. The building was funded by public subscriptions and money-raising events to commemorate the coronation of King George V in 1911. The tiny hospital had three single bed wards, three staff bedrooms and a small operating theatre.

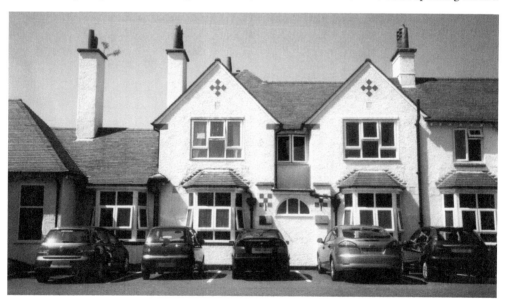

The hospital has been enlarged over the years, with a major extension in the late 1930s. It was renamed the Skegness and District Hospital. A maternity unit was subsequently opened and closed, before the NHS took over the hospital in 1981. A day centre and day unit was officially opened by the Earl of Scarbrough on 12 July 1985, which could accommodate up to twenty-five elderly people. At the time of writing, Skegness Day Centre can cater for up to forty-five people a day under the management of Mandy Hayes. The Accident & Emergency entrance remains on Dorothy Avenue, with the main entrance and parking area on Lincoln Road. (Photo by the late Winston Kime)

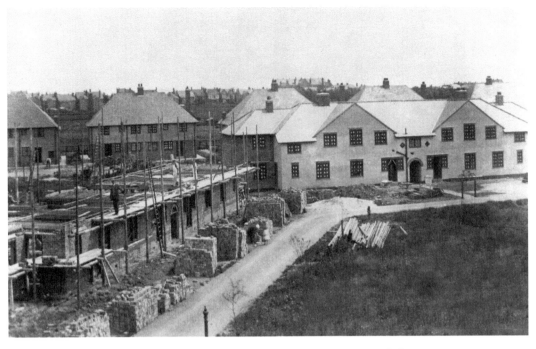

The town's first council houses were on the Richmond Drive Estate, including Tennyson Green, seen here in the course of construction in June 1921. This photograph was taken by Mr T.H. Pennington, Skegness Council's Clerk of Works.

The Tennyson Green houses, constructed in 1921, are still neat and tidy with a well-maintained Green. (Photo by the late Winston Kime)

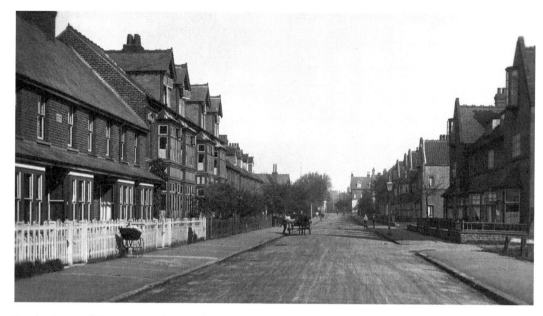

Nottingham and Notts Women's Convalescent Home in Grosvenor Road (with the attic windows). The building was opened by Sir Charles Seely, MP and High Sheriff of Nottingham, in the early twentieth century, but was converted into residential housing in the 1930s. This postcard was mailed in 1921.

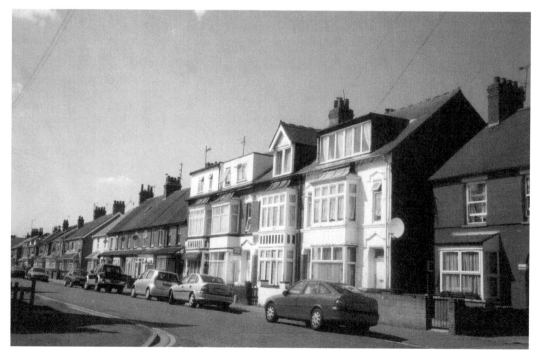

The former Nottingham Women's Home in Grosvenor Road, painted white and now used for residential occupation. (Photo by the late Winston Kime)

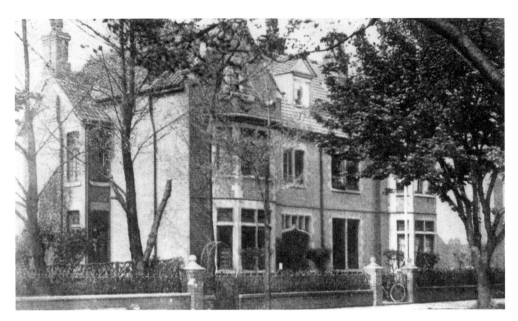

Number 29 Algitha Road was built as the Council Offices in 1895, for the newly formed Skegness Urban District Council (UDC). In 1920, the Earl of Scarbrough sold his Roman Bank Estate Office to the UDC and took 29 Algitha Road in part exchange. The Earl later moved his offices to the old Hall on Roman Bank and sold the Algitha Road premises to a private business. For a time in the 1950s the owners were Skegness Town Football Club.

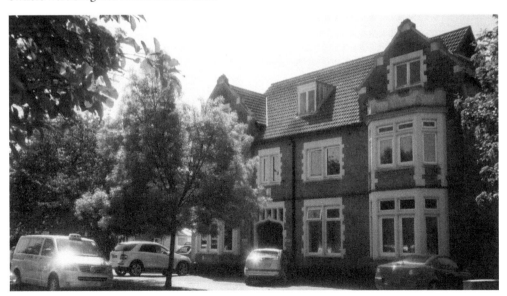

Number 29 Algitha Road is now utilised as private offices, along with the majority of properties in this area. Before the war the houses were popular as guesthouses, advertised as 'apartments', with guests providing the food for the landlady to cook. With the advent of cars, bed & breakfasts and boarding houses became the norm. The old Hall mentioned in the above photograph was demolished in March 1988, in preparation for the building of the residential flats known as Sutton Court. (Photo by the late Winston Kime)

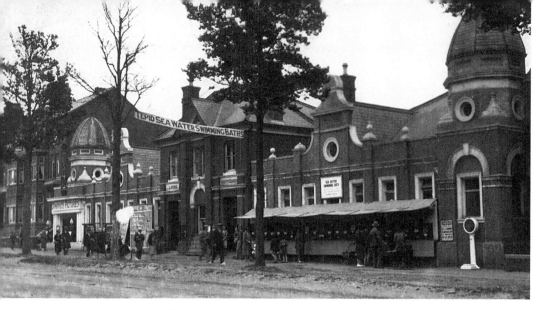

The Skegness Hot and Cold Swimming Baths Co. Ltd erected the public indoor seawater baths in Scarbrough Avenue in 1883, at a cost of £4,000, consisting of ladies' swimming bath, with seven private baths and the same for gentlemen. When mixed bathing was legalised around the beginning of the twentieth century, the ladies' pool was boarded over to become the Kings Theatre and later a cinema of that name. Although Scarbrough Avenue was laid out in the 1870s, it remained a gravel road until 1930, when it was metalled and kerbed.

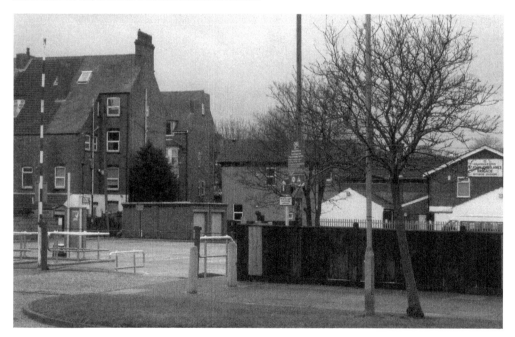

The seawater baths were totally destroyed in a heavy air raid on 24 October 1942, fortunately with no fatalities. The site (above) was later purchased by Skegness Urban District Council and converted to the present car park close to the seafront. On the opposite corner, nine airmen were killed in the same raid whilst billeted in a hotel, which has since been rebuilt as the Sea Breeze care home. (Photo by Ken Wilkinson)

3

THE SEASHORE:
NORTH OF THE PIER

This photograph appeared in 'The Skegness Holiday Guide' of 1958. The pier was officially opened on Whit Monday 1881, at a cost of £21,000. During the following summer a ferry service operated across the Wash to Hunstanton. The Dutch Schooner *Europa*, laden with ballast, on the way to King's Lynn, ploughed through the pier on 20 March 1919. A permanent repair was not completed until 1939. Storm damage on 11 January 1978 took out two sections of the pier. The remaining centre section was removed in 1984. Work to dismantle the pier head started in October 1985, but an unattended incinerator ignited nearby woodwork. The resulting fire left the pier head a mass of blackened steel. This was later removed when tides permitted. Today the remainder of the pier, most of it undercover, still attracts the holidaymakers with its amusements and cafés. It is now owned by members of the local Mitchell family.

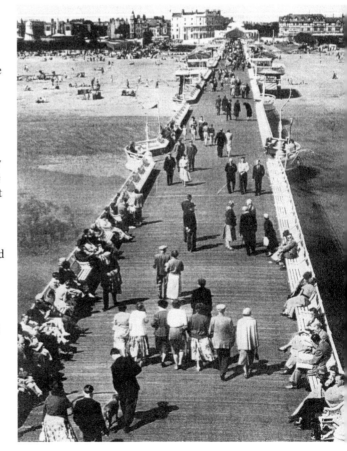

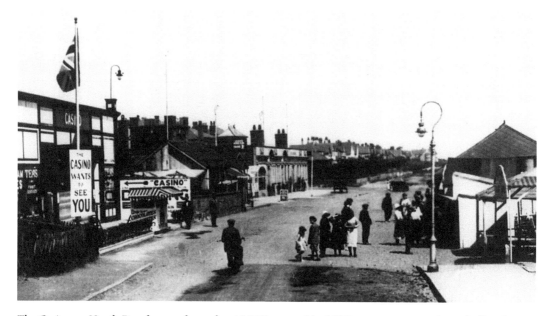

The Casino on North Parade, seen here about 1930, opened in 1922 as a restaurant, dance hall and indoor skating rink. The site had previously been occupied by the Alhambra open-air skating rink. During the Second World War, the Casino became an Airman's Mess, which was an ideal venue as it could seat over 900 hungry servicemen.

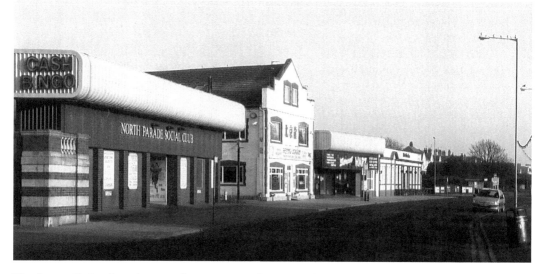

The former Casino later became the Winter Gardens. Murphy Radio Ltd opened a factory in the building in 1952, before moving to a new factory on the Industrial Site off Wainfleet Road, under the new name of Rank Bush Murphy, employing around 500 workers. This factory closed in 1975 due to a recession. The old Casino is now the North Parade Social Club and Bingo Hall. The centre gabled building is a Chinese restaurant called Beijing Dragon, established in 2004, and the building next door was formerly Harrisons. Once used for skating, it has more recently been a nightclub called The Street and, at the time of writing, is due to have a change of use to become the New Day Christian Centre. (Photo by Ken Wilkinson)

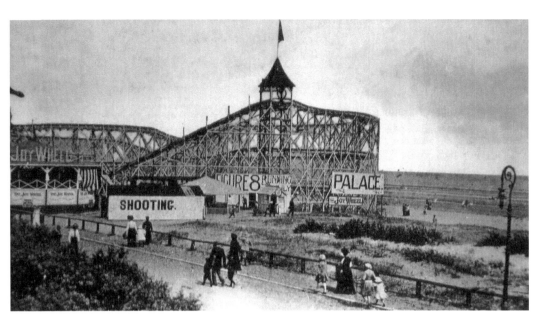

The Figure 8 Railway opened in 1908 and is pictured here around 1910. The carriages were drawn up the slope by an endless chain; they then swept down the descending track by gravity. It survived until 1970, although from 1930 it lost its popularity after being overshadowed by the Big Dippers provided by Butlin's and later the Botton Brothers in the main amusement park south of the pier.

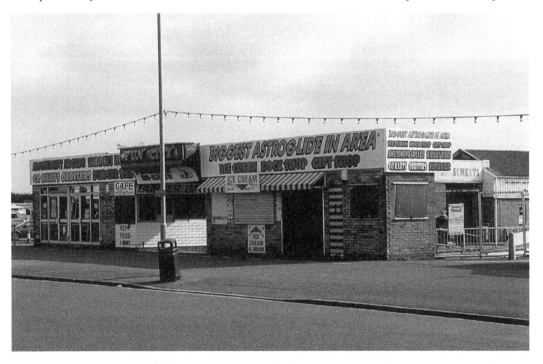

The site today is now called Fun City, an area still used for amusement rides and cafés – one of its main attractions is the large Astroglide. Beyond is the north shore car park and also the Xcite Skatepark – the Lincolnshire Extreme Sports Centre. (Photo by Ken Wilkinson)

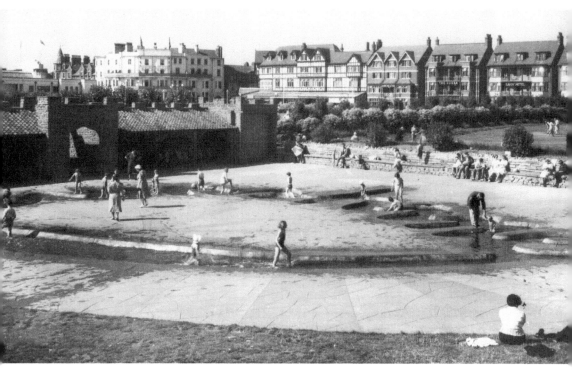

The Sunshine Paddling Pool on the north side of the pier, on a postcard stamped 1956. This was always a popular venue where parents could sit and watch their children play safely in the water.

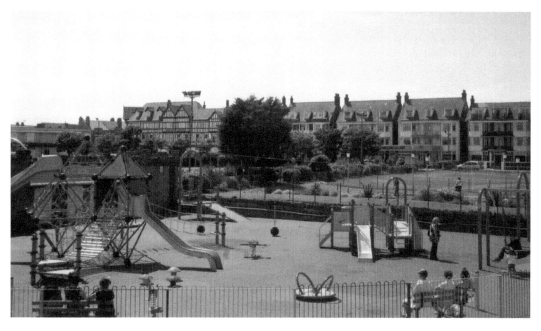

The former Sunshine Paddling Pool was reconstructed in 2010. It now has slides, climbing frames and other attractions in an enclosed area. (Photo by the late Winston Kime)

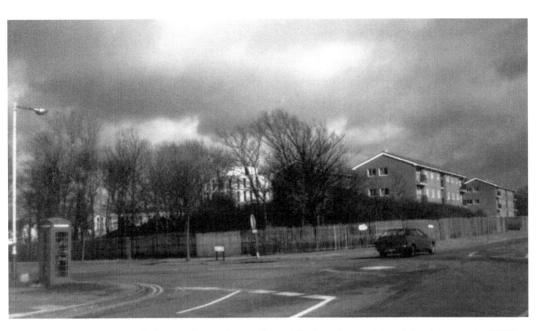

When the last part of the Jungle was being cleared for housing and hotel development in 1982, a strong protest was led by the late Councillor Harold Fainlight, who attempted to preserve this small corner of Castleton Boulevard with its flowerbeds and seats where people could rest while watching the incoming road traffic. They were finally outvoted, however, and the builders took the valuable site for houses and flats. The County Hotel is just off the picture, to the left of the telephone kiosk. (Photo by the late Winston Kime)

The developed area with the trees now nearly all gone. The area is now built up with houses on Castleton Boulevard and flats on North Parade. (Photo by the late Winston Kime)

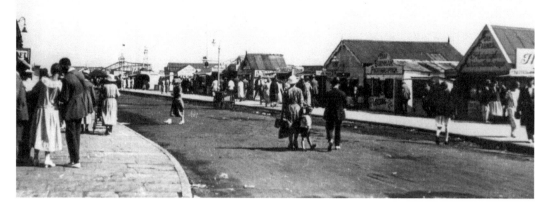

North Parade, c. 1920. Looking north from the pier to the Figure 8 is a long line of stalls: the first two on the picture are photographic studios; others are rifle ranges, swing boats, skittle alleys and other amusements. These were all swept away to allow for the construction of more permanent attractions at Butlin's new amusement park on the south side of the pier in 1929.

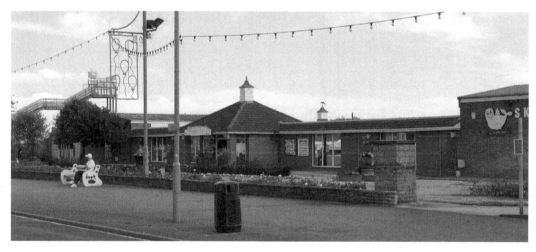

Skegness Natureland was opened on 1 July 1965 by the Skegness Urban District Council with curator-manager John Yeadon and part-time Technical Director George Cansdale, television's 'Zoo Man'. Today, brothers Duncan and Richard Yeadon are co-proprietors of the Natureland Seal Sanctuary, a popular venue throughout the year – feeding time in the seal and penguin pools are always entertaining. Other attractions include the Tropical House with reptiles, the Floral Palace with its exotic plants and giant butterflies, and Pet's Corner. Natureland has also become an authority on seal conservation. Having built a seal hospital in 1989, they rescue on average around forty seal pups a year found abandoned on local beaches, before they are released back into the sea. (Photo by the late Winston Kime)

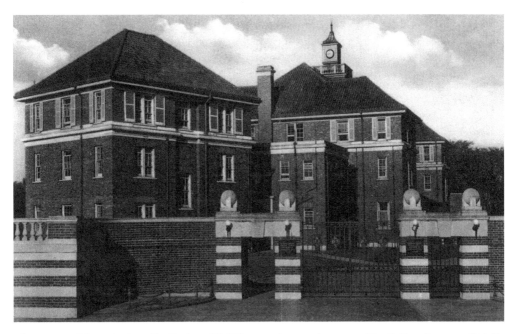

The National Deposit Friendly Society (NDFS) convalescent home on North Parade was officially opened by HRH Princess Marie Louise on 28 May 1927 as a memorial to nearly 10,000 members of the NDFS who died in the First World War. Minister of Health, Neville Chamberlain, who later became Prime Minister, also attended the ceremony.

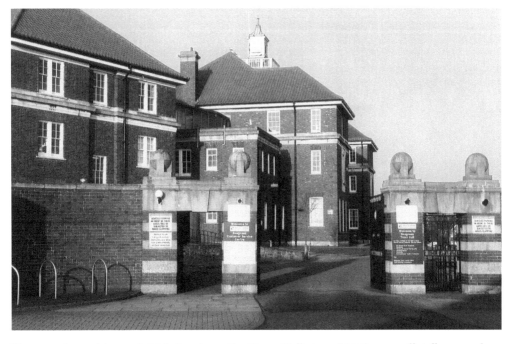

The convalescent home (which has been the Town Hall since 1964), was officially opened on 10 June 1964 by HRH the Princess Royal, supported by Skegness Urban District Council Chairman, Councillor Arthur Wise. (Photo by Ken Wilkinson)

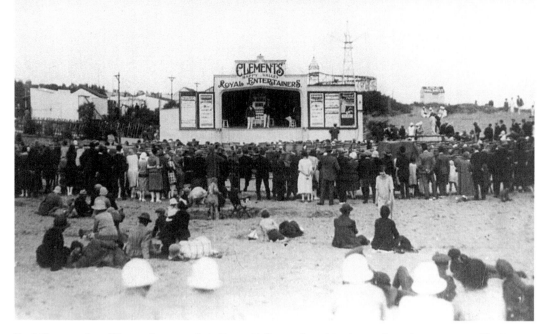

Fred Clements Royal Entertainers on their Happy Valley pitch on North Parade in the 1920s. Fred had a great following with morning and afternoon performances on the beach and at the Arcadia Theatre in the evening. The show was forced to close, along with other stallholders on North Parade, in 1929.

The Suncastle was built on the site of Clements Royal Entertainers in 1932 and was equipped as a solarium with ultraviolet ray lamps producing artificial sunlight. It never caught on, however, and reverted to a pleasant retreat for refreshments and light music. Bowling greens, bordered by a long colonnade, were added and several open tournaments are held there each year. The Suncastle is popular today as a family venue in the summer season, and for social events during the winter months. (Photo by Ken Wilkinson)

4

THE SEASHORE:
SOUTH OF THE PIER

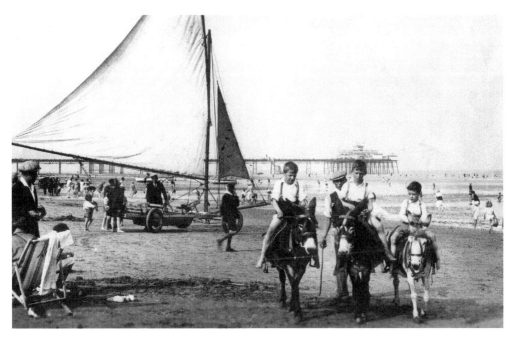

This pre-war photograph depicts the pier (opened in 1881) and all the pleasures of the beach: donkey rides, sand-yachts, sea bathing, seagoing pleasure craft and deckchairs.

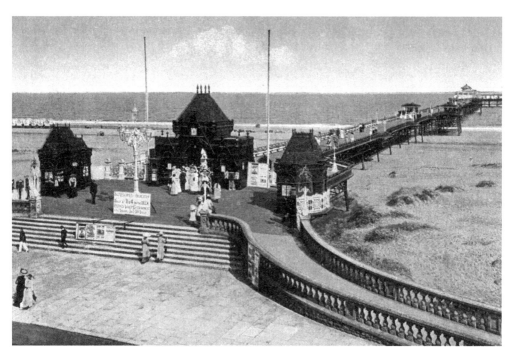

A postcard view of the original main entrance to Skegness Pier, *c.* 1910. Note the balustrade ramps on either side, providing access for perambulators and bath chairs.

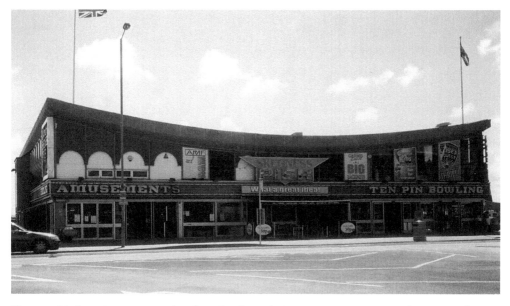

Skegness Pier's main entrance, taken from Scarbrough Avenue, was reconstructed in 1937. The pier was later bought by the late Mr R.G. Mitchell, a well-known engineer and entrepreneur. The company is now managed by his son, Robin, and daughter Carolyn. The change to the present layout – bringing it to ground level – took place in 1972. The pier has ten-pin bowling with full sized lanes, in addition to amusements, a children's play area and cafés. (Photo by the late Winston Kime)

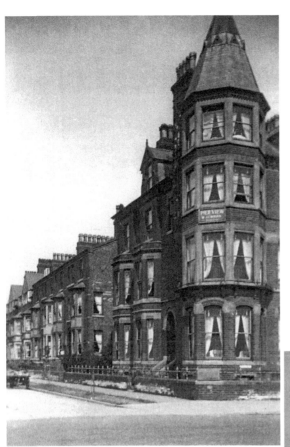

Left The Pier View Hotel on the corner of Grand Parade and Prince Alfred Avenue, *c.* 1890.

Right The former Pier View Hotel is now the Oasis Amusement Arcade. Prince Alfred Avenue is still popular for holiday accommodation. (Photo by Ken Wilkinson)

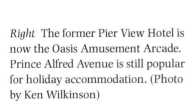

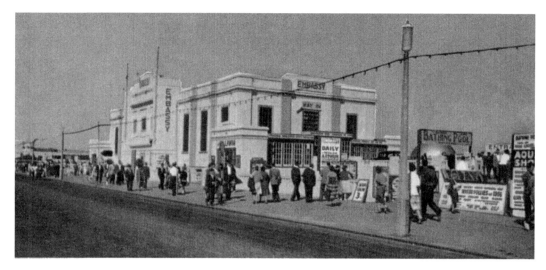

The original Embassy Ballroom of 1929. Seen here in 1958, the building underwent a major conversion in 1982 to become the multi-purpose Embassy Centre, when a new auditorium was constructed. With seating for up to 1,200, the lower 760 seats were designed to fold away in order to make room for exhibitions and trade fairs. (Photo by Walter North)

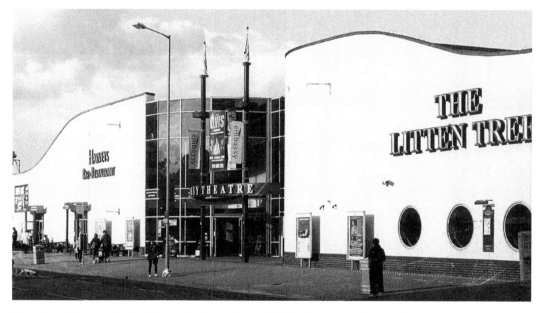

More demolition and rebuilding took place during 1999. The new Embassy Theatre Complex was officially opened by Ken Dodd on 3 August 2000, on behalf of the East Lindsey District Council and the Government Office for the East Midlands. The main entrance and foyer also holds the Tourist Information Centre and theatre ticket office. The frontage is flanked by The Litten Tree on the right and Harveys to the left; both are popular restaurants and bars. The theatre attracts many famous artists throughout the year. Local dance teacher Janice Sutton, famous for her theatre school, has trained thousands of children over many years to professional standards, producing shows at the Embassy Theatre once a week during the summer season and also pantomimes at Christmas. (Photo by Ken Wilkinson)

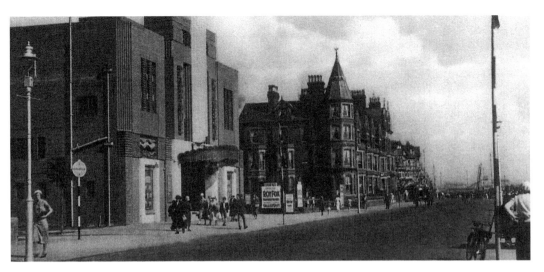

The Parade Cinema on the Grand Parade opened in December 1933, a month before the closure of the Lawn Cinema on the High Street. The cinema closed in 1973 and was converted into an amusement arcade in 1976. (Dennis Plant Collection)

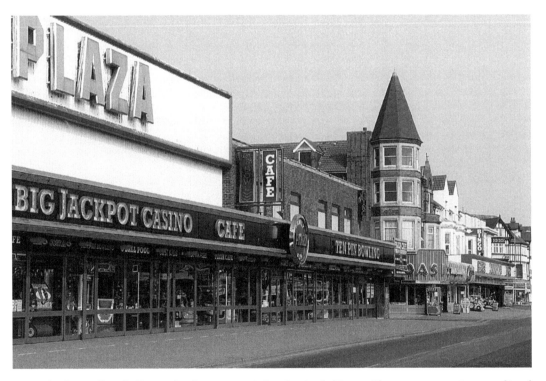

The former Parade Cinema has been converted and extended to provide an amusement area, café and ten-pin bowling. The complex is now called The Plaza. (Photo by Ken Wilkinson)

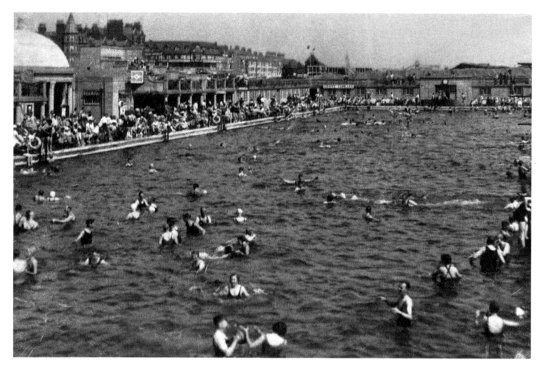

This photograph, taken in the 1950s, shows the popular large open-air swimming pool. It was adjacent to the Embassy Ballroom and Restaurant, and the Orchestral Piazza, an open space with a domed bandstand, all demolished in 1982 to make room for the new Embassy Theatre and car park.

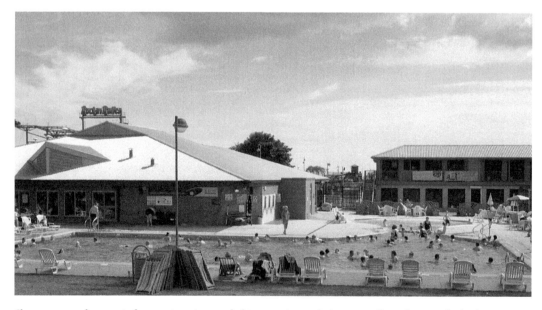

Skegness now has an indoor swimming pool, fitness suite and also a small outdoor pool, the latter both shown here. (Photo by the late Winston Kime)

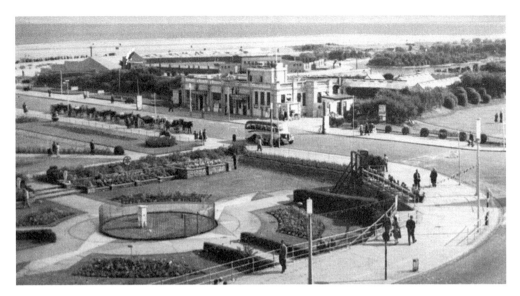

Clock Tower Pullover and Gardens, *c.* 1930. This postcard depicts the Compass Gardens and the Foreshore Centre, which was the former Café Dansant, prior to 1920. The boating lake can be seen behind. The tiled compass is engraved with the names of cities worldwide, pointing in their direction and with mileage distances. In the centre of the compass, surrounded by the iron railings, is the meteorology station, where temperatures and rainfall are measured; this facility is now relocated near the Suncastle on North Parade.

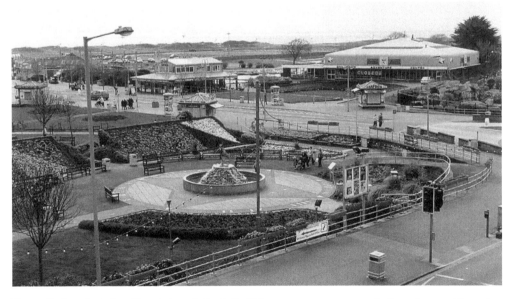

Tower Esplanade today. The statue of the Jolly Fisherman now commands the prime position atop the fountain in the centre of the Compass Gardens. Commissioned by the town mayor, Cllr Harold Fainlight MBE, JP, it originally stood on a circular plinth. It has been a symbol for the resort since 1908, and was first used to advertise train trips to Skegness from King's Cross at 3 shillings a trip. The large building on the right, Panda's Palace, provides a much needed all-weather facility, including a large children's adventure play area, with climbing nets, slides, and a ball pool. (Photo by Ken Wilkinson)

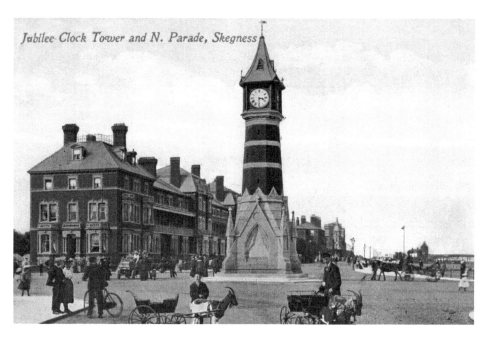

Jubilee Clock Tower and N. Parade, Skegness

This postcard was posted in 1911 and shows the Clock Tower and Osbert House, the latter built in the late 1870s as a hotel at the south end of Frederica Terrace. The building later became Butlin House, headquarters of the Butlin's organisation. Note the goat-carts in the foreground.

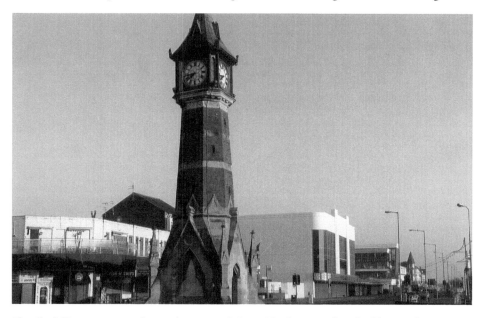

The Clock Tower now stands on a busy roundabout. The large modern building in the centre is Lucky Strike, opened in 2009 and owned by Brian Bell, providing three floors of amusements, including a large children's play area and café. It is built on the site of the great fire of 16 August 2007, which destroyed a nightclub, amusement arcades, the Jolly Fisherman pub (formally the Callow Park Hotel) and the rest of Frederica Terrace, with the exception of the Ex-Serviceman's Club, which escaped with only water damage. (Photo by Ken Wilkinson)

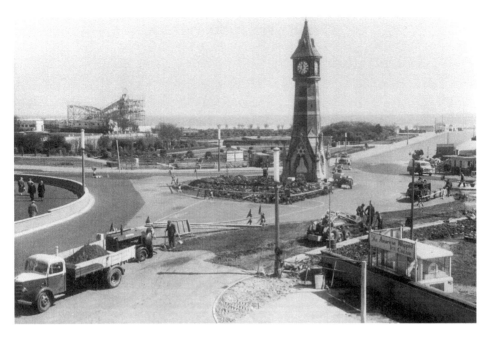

Skegness Council workers engaged in the construction of the Clock Tower roundabout in 1960. This photograph was taken by the Council foreman, Ossie King.

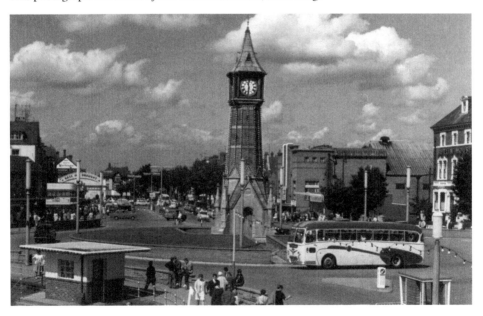

An intriguing study of the area around the Clock Tower, taken by the late Jim Stuart MBE, possibly around 1970. Note the ticket man (far right) sitting waiting for cars to park on the esplanade, and the flat-roofed pay box on the putting green. Part of Butlin House is also visible on the far right; this was demolished in January 1972 and replaced by shops and a restaurant. Jim Stuart was a well-respected gentleman in Skegness, known for his work at the Derbyshire Children's Home in Scarbrough Avenue, which he managed for many years with the help of his wife; he died at the age of sixty-six.

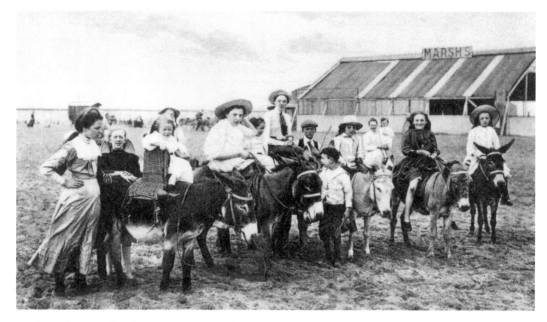

Donkey rides were already an attraction on Skegness beach at the beginning of the twentieth century, seen here on the south side of Skegness Pier. The building on the right is a theatre operated by Will Marsh and his Merrie Men. (Dennis Plant Collection)

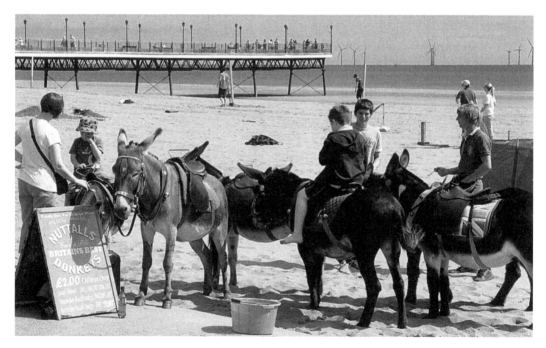

Donkey rides have been popular throughout the years. The local family names of Epton, Elliot and Hancock have been synonymous with donkeys on Skegness beach for generations. One of Nuttall's donkeys – Pedro – won Britain's Best Beach Donkey Award in 2007. Note the truncated pier and the wind farm turbines, 5 kilometres out at sea. (Photo by David Kime)

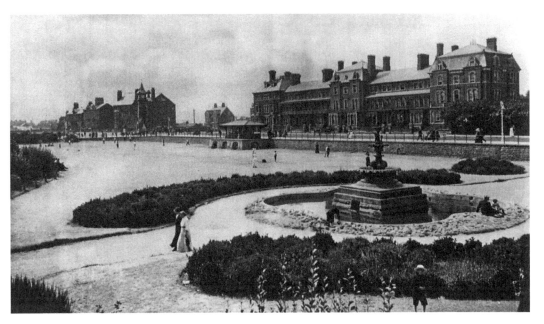

Steps from the Grand Parade led down to the Marine Gardens and fountain, and the beach. This area later became the site of the Embassy Ballroom and open-air bathing pool. This photograph was copied from a postcard dated 1915. Note the promenade retaining wall, which also served as a sea defence, constructed of limestone blocks brought down by rail from the Earl of Scarbrough's Roche Abbey quarry; the wall and railings extended as far south as Derby Avenue.

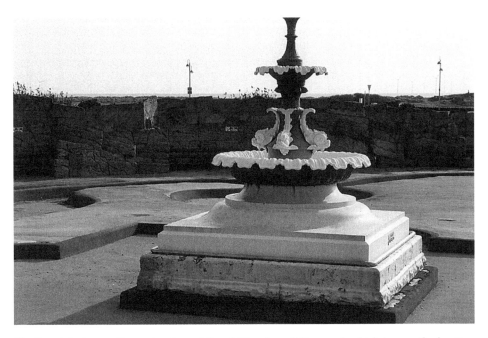

The fountain is now the centrepiece of the children's paddling pool, which is near the boating lake. The fountain started life in Lumley Square, where it also served as a gas lamp standard before it was erected in the Marine Gardens. (Photo by Ken Wilkinson)

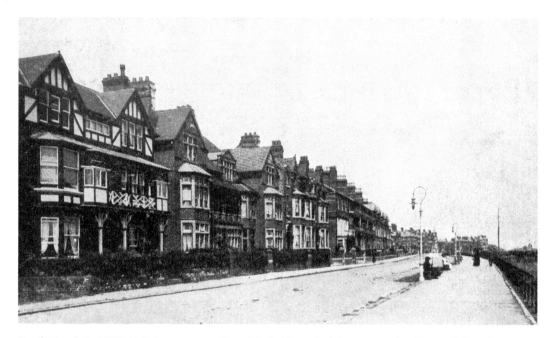

South Parade in 1910. D.H. Lawrence, author of *Lady Chatterley's Lover*, stayed at his aunt's boarding house (shown here in the foreground) for a number of weeks in 1902 while convalescing from pneumonia as a teenager.

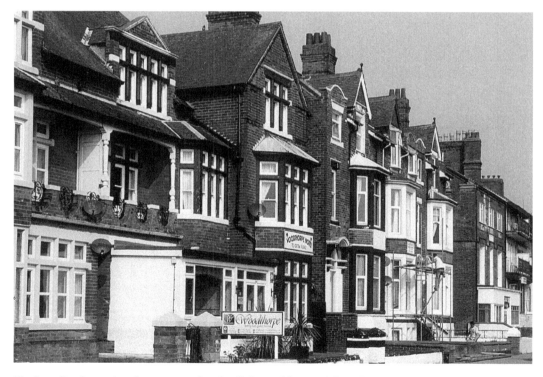

The boarding house is today a private hotel called Woodthorpe. (Photo by Ken Wilkinson)

5

CHURCHES
AND SCHOOLS

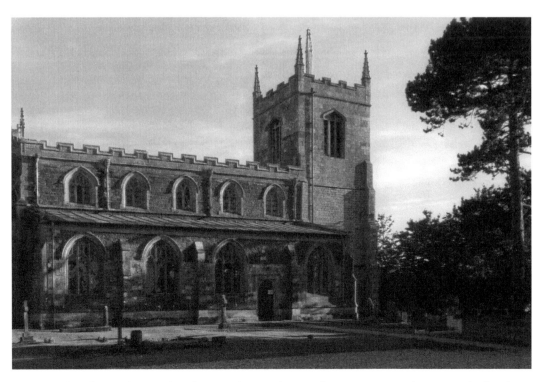

St Mary's Church, Winthorpe. This photograph was taken one late evening in mid summer; the detail was enhanced by the setting sun on this, the north side of the church. (Photo by Ken Wilkinson)

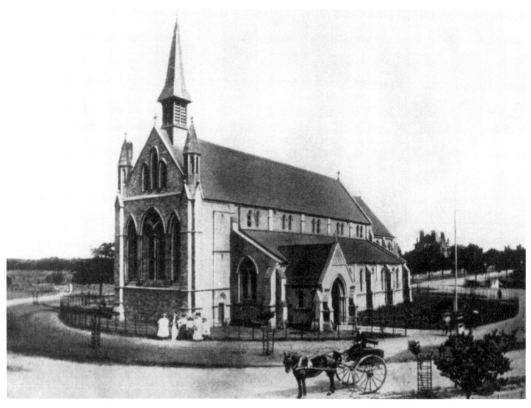

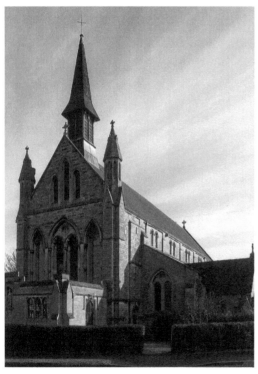

Above St Matthew's Church, *c.* 1900. The Earl of Scarbrough donated the site plus £3,000. The architect was James Fowler of Louth, and the building was constructed from Ancaster stone. The Countess of Scarbrough laid the foundation stone on 5 November 1879. The original tower and spire for the church had to be abandoned because of foundation problems, and instead they eventually placed this light bell turret on the roof. The roadway around the church was known as Powletts Circus. The photograph was taken from 'Picturesque Skegness' (1908).

Left A war memorial was built on the south side of the church in 1923. The single storey choir vestry was added to the west front in the early 1930s. In 1938, St Matthew's parish church began to sink on its foundations and major repairs had to be carried out. Whilst this work was in progress, the church and the surrounding road and footpaths had to be closed. (Photo by Ken Wilkinson)

St Clement's Church, Skegness. After old Skegness was almost swept away in the great sea flood of 1526, the impoverished inhabitants began building a new parish church. In their deprived state it had to be restricted to a basic design and situated beyond reach of the still-threatening sea. The church became almost derelict for a number of years; it was accessible only by field paths. It was Canon Morris who brought it back into use in the 1930s. The church is pictured here on this postcard published by G.J. Crofts, Drapery Warehouse, in 1908.

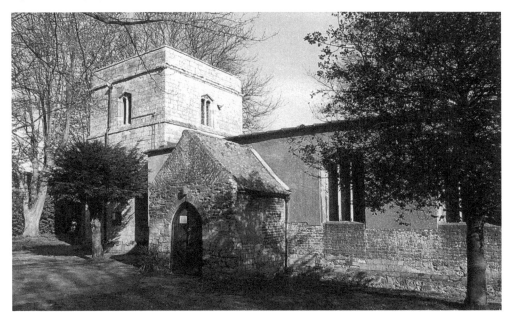

The fifteenth-century St Clement's Church stands in the wooded churchyard. Since 1985, nearly all burials have taken place at St Mary's Church, Winthorpe. The church has been more accessible since Lincoln Road was extended and regular services are still held here. (Photo by Ken Wilkinson)

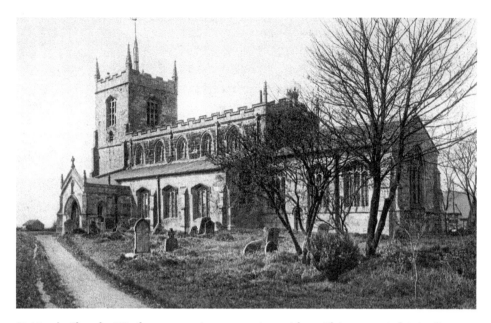

St Mary's Church, Winthorpe, was in a separate parish until incorporated into Skegness in 1926. Mainly fifteenth century, St Mary's is the successor of a much earlier church and contains ornately carved woodwork. The church was restored in 1881 by the benefactor Annie Walls of Boothby Hall. On the south-east corner of the tower is an inscription cut into the stone, 'H W 1837'. This is 2.5 metres above the ground and was the high water level on the sea side of Roman Bank. Close to the church was the Winthorpe village school, built in 1865; it could accommodate up to fifty children of all age groups.

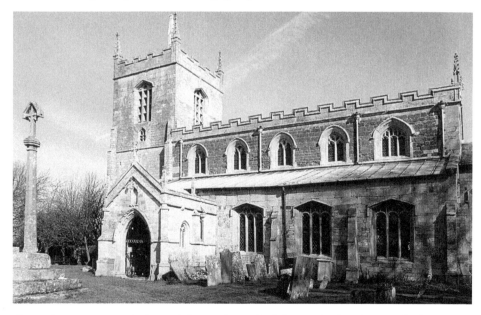

The ancient stone cross in front of the south porch of St Mary's Church was rebuilt in 1926, to form the Winthorpe parish war memorial. The village school closed in 1951 when the Seathorne Junior School opened. The old school building later became the Charnwood Tavern.

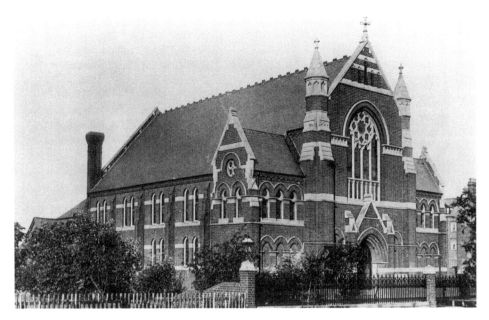

The Wesleyan Methodist Church in Algitha Road was officially opened on 13 July 1882. During the Second World War it suffered heavy bombing in the early hours of Sunday, 16 February 1941. The church was closed but services continued to be held in the Sunday school.

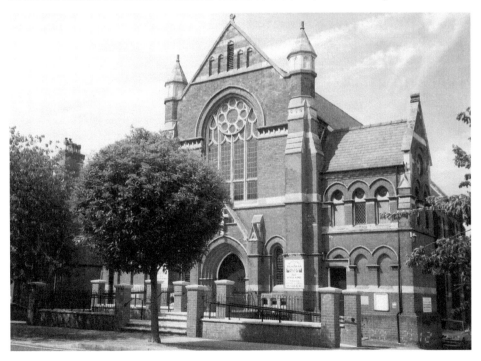

This photograph shows the newly erected wall and railings, replacing the iron gates and railings which had been used for armaments during the Second World War. An air raid totally destroyed a pair of houses on the east side of the church; the site was afterwards converted into the church car park. (Photo by the late Winston Kime)

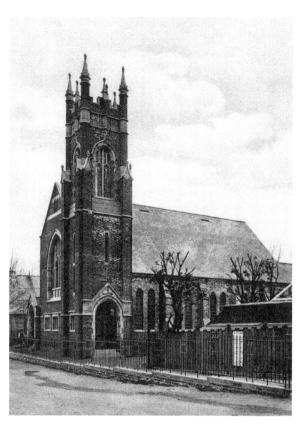

Left St Paul's Baptist Church. This red-brick gothic church was designed by Skegness architects John Wills & Son. It was officially opened on Good Friday, 14 April 1911, and was dedicated to St Paul. The church replaced a tiny tin tabernacle, built of corrugated iron in the 1890s. At that time, Beresford Avenue was an unmade private road and access to the church was via a footpath from Lumley Road.

Below The tiny tin tabernacle became the Sunday school until the new hall was built in 1952. This corner of Hildred's shopping centre was once the site of the Lawn Theatre and Cinema. (Photo by Ken Wilkinson)

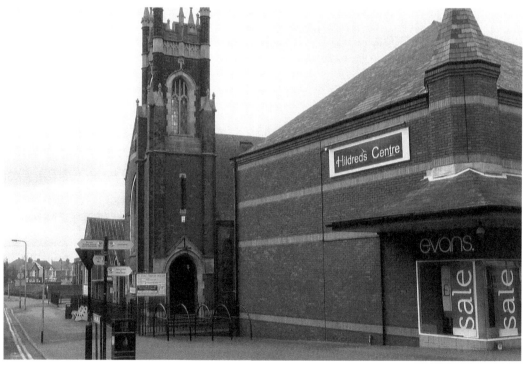

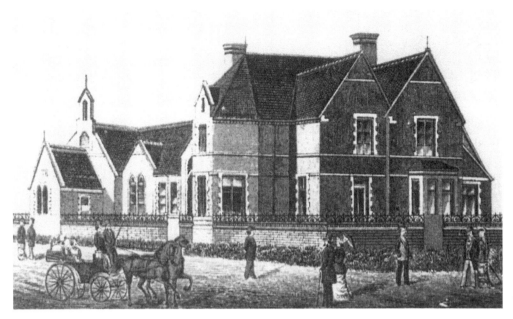

Skegness National School, Roman Bank. This image was taken from a nineteenth-century picture book, before photography was widely used. Opened in 1880, it was finally displaced by the County Council's Lumley Secondary School in 1932, when pupils and headmaster Harry Bamber, along with other staff, transferred to the new building in Pelham Road. The headmaster's residence was on the right, fronting Ida Road.

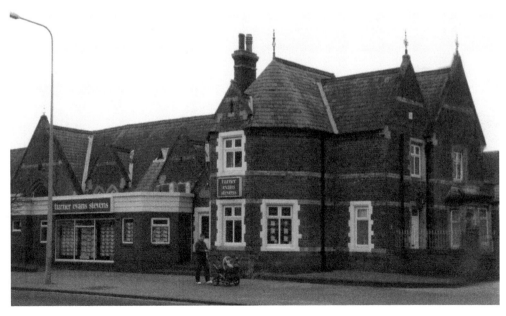

When the school closed in 1932 it became Geo F. Ball's estate office. It is now occupied by Turner Evans Stevens, auctioneers and estate agents. Halifax Building Society had a branch in this building until 2011; this office is now a branch of the Santander Bank. (Photo by Ken Wilkinson)

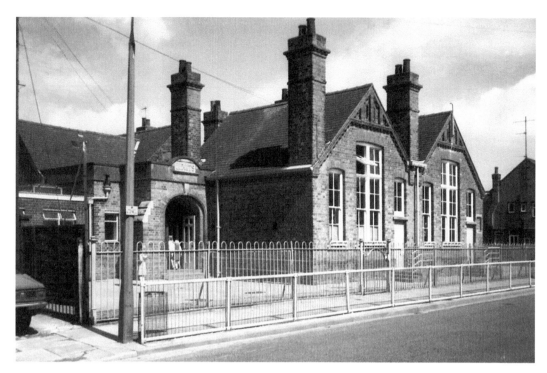

Skegness County Infants' School in Cavendish Road, pictured just before it was demolished in February 1998. This was the first council school in the town when it opened in 1908.

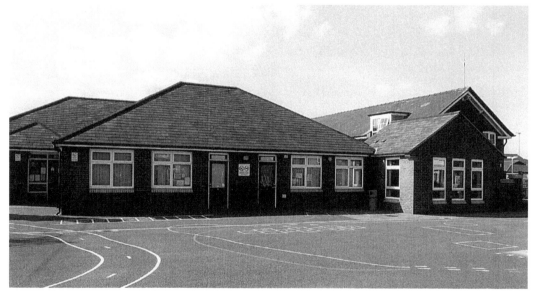

Skegness County Infants' School's modern buildings are set back from the site of the old school on Cavendish Road. They were officially opened on 21 May 1998 by HRH the Duke of Gloucester. The land between is now a pleasant play area. The buildings to the rear used to be the Skegness County Junior School, but have now become part of Skegness County Infants' School. Mrs Sue Roy is, at the time of writing, the head teacher. (Photo by Ken Wilkinson)

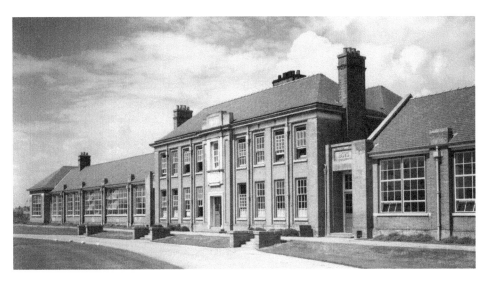

Skegness Grammar School opened in Vernon Road in September 1933; built at a cost of £35,000. The first headmaster at this school was Kenneth G. Spendlove, who had been headmaster of Magdalen College School, Wainfleet, which Skegness Grammar School replaced. The school started with just 190 pupils. Magdalen College was established in 1483 by William of Waynflete, born in Wainfleet as William Patten.

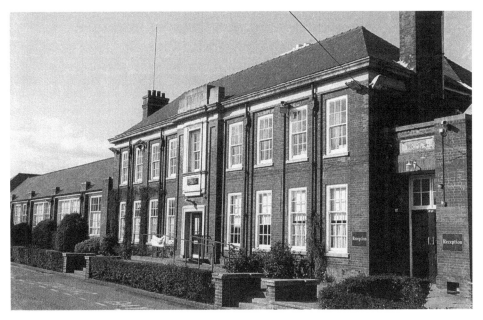

The Grammar School is today much enlarged, with boarding facilities for around seventy pupils at the former Wainfleet Hall since 1991. In 1989, the school became the first grant maintained school in the country under the new Thatcher legislation. Education Secretary Kenneth Clarke gave it official approval in February of that year, the minister himself later visiting the school. A new head teacher, Mr D.A.T. Ward, was appointed in May 2011, coming from his previous headship at Saint Felix School in Suffolk. Mr Ward took over the role from former headmaster Mr Roy Ballantyne. (Photo by Ken Wilkinson)

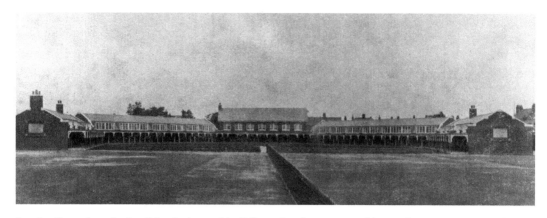

Lumley Secondary Senior School, situated in Pelham Road, was opened by Lindsey County Council on 17 October 1932, with headmaster Harry Bamber. In 1986, this school was incorporated into the Earl of Scarbrough High School, formerly the Morris School, on a different site. The building in the photograph was demolished in 1993.

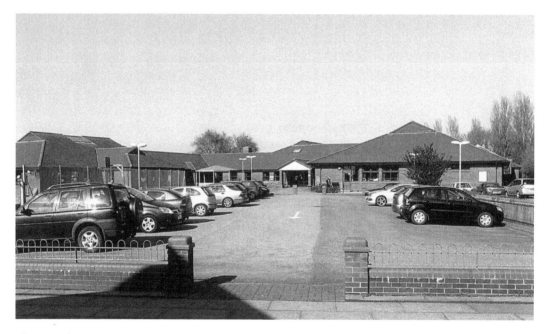

The new Skegness County Junior School, erected on the same site in 1994. The school opened on 18 January 1995. Mr Tom Smith is, at the time of writing, the head teacher. (Photo by Ken Wilkinson)

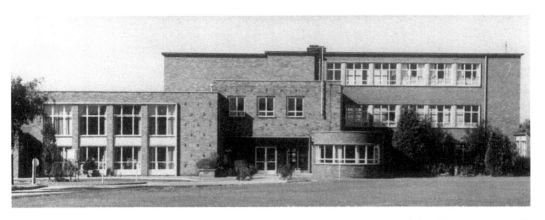

Skegness Morris Senior School opened on Church Road North in 1957, with headmaster Mr Ronald Johnson. The school was named to commemorate the former Skegness rector, Canon Arthur H. Morris. Mr Brian Drinkall was appointed as headmaster in 1975, a post he held until September 1986. It was then merged with the Lumley Secondary School to form the Earl of Scarbrough High School. The new building fronting Burgh Road was not completed until 1988.

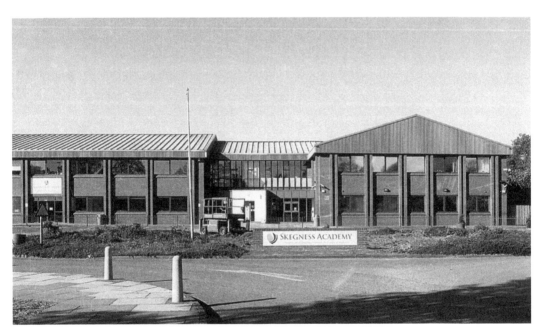

The Earl of Scarbrough School was renamed St Clements College in 2005, at which time the principal was Mr A. Munnerly. It then became the Skegness Academy in September 2010; the principal being Mr Kelvin Hornsby. The school is part of the Greenwood Dale Foundation Trust Group of Academies. (Photo by Ken Wilkinson)

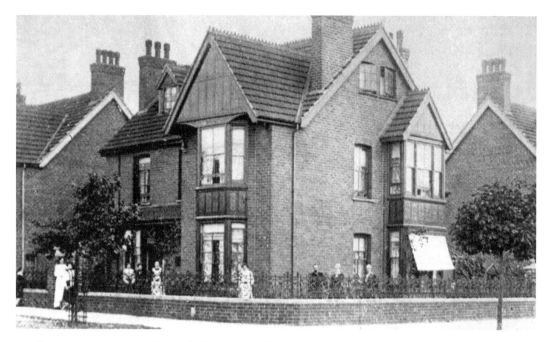

Lyndhurst Preparatory Girls' School, photographed here in the 1920s on the corner of Algitha Road and Lumley Avenue. It had earlier been Bryntwen High School, established in 1899. It became the Nottingham Co-op Social Club and, later, the Lyndhurst Social Club for a long period.

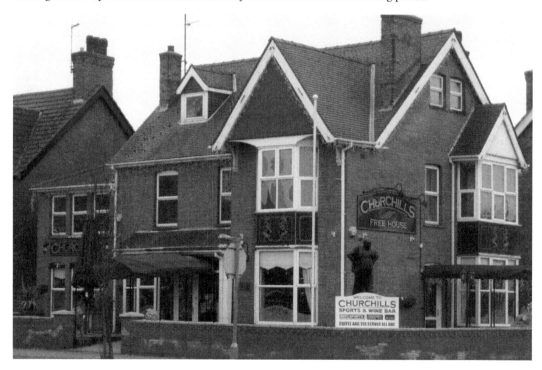

The building is now Churchill's Sports and Wine Bar. The proprietor is, at the time of writing, Paul Farrell. Note the statue of Winston Churchill, centre right. (Photo by Ken Wilkinson)

6

HOTELS, AND
OUT AND ABOUT

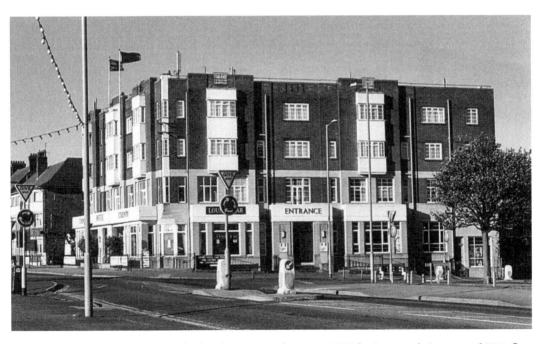

The County Hotel, North Parade. The hotel was opened in June 1935 by Bateman's Brewery of Wainfleet on the site known as the 'Jungle.' It was here that Billy Butlin cleared a portion of land to erect his first stalls in 1927. Billy Butlin last visited Skegness in 1977 to switch on the town's illuminations, and, on that occasion, he stayed in the County Hotel. Sir William Butlin died in 1980. (Photo by Ken Wilkinson)

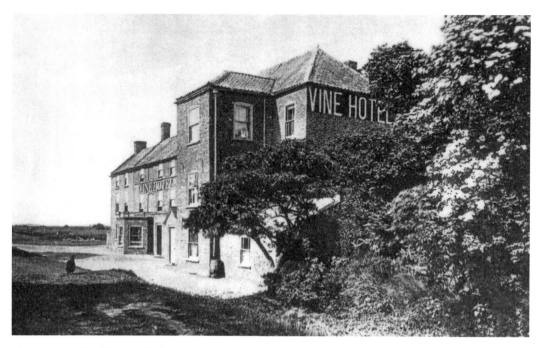

The Vine Inn, the oldest public house in the town, dates back to 1770. It was then called the Skegness Inn. The landlord, Joseph Dickinson, advertised the hotel in 1772 as standing on 'as clean a shore as any in England.' Thomas and Mary Enderby took over in 1828, when it became known as Enderby's Hotel. They held the licence until 1850. The succeeding landlord was Samuel Joseph Clarke. It was during that year that the hotel was named the Vine Hotel. When the 9-hole Seacroft Golf Links began operating in 1895, the first green came almost up to the building. Five years later the links expanded to 18 holes and moved south to Drake Road.

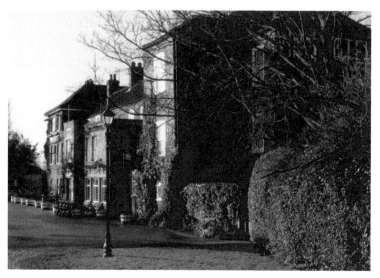

Recent major refurbishment has brought this ancient hotel up to modern standards, with twenty-five bedrooms, all with en-suite facilities. The Vine Hotel is now a Best Western Hotel, but still retains its old-world charm, popular as a venue for weddings and other social events. (Photo by Ken Wilkinson)

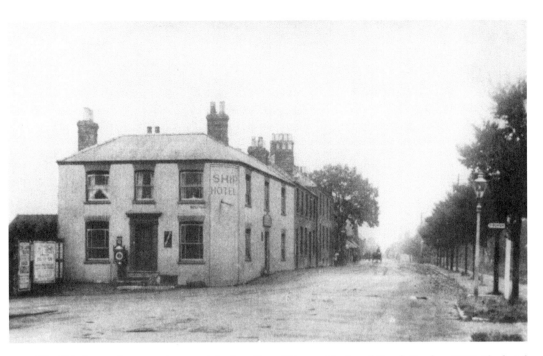

The Ship Inn makes a rural scene at the junction of Roman Bank and Burgh Road, *c.* 1800. The hotel was demolished in 1936.

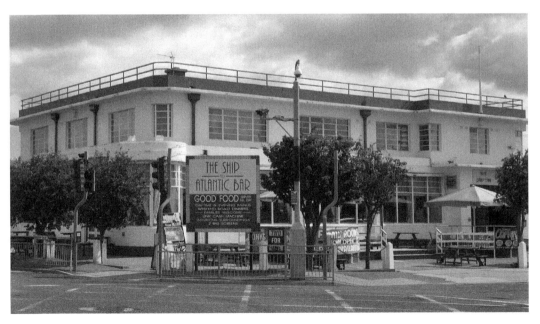

The new Ship Inn was built in Art Deco style on the junction of Roman Bank and the newly constructed dual carriageway, Castleton Boulevard, in 1934. The town's first traffic lights were installed at this junction at the same time. (Photo by Ken Wilkinson)

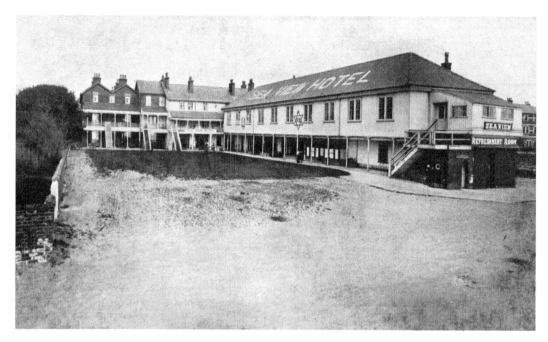

The Sea View Hotel, *c.* 1900. The buildings on the right are facing Sea View Road, which opened in 1862.

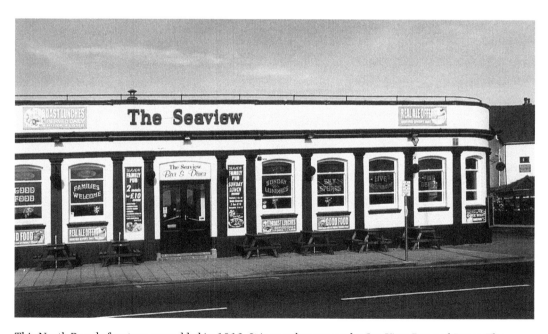

This North Parade frontage was added in 1913. It is now known as the Sea View Bar and Diner. The former hotel is now apartments. (Photo by Ken Wilkinson)

The Lumley Hotel in Lumley Square, 1880. A year later, a single-storey extension was added called the Long Bar. It had a large clock over the entrance to inform the railway traveller across the road that there was still time for a quick drink.

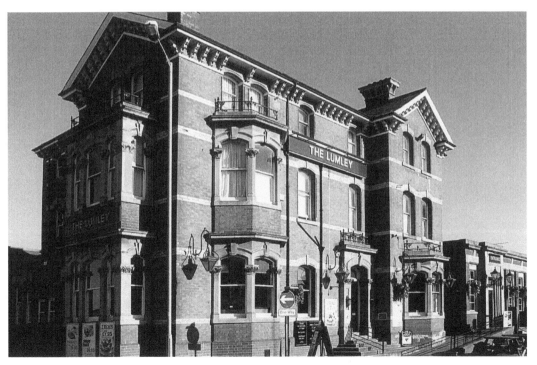

The Lumley Hotel today. The Long Bar was demolished in 1987 to make way for an Iceland supermarket, which opened in April 1993. (Photo by Ken Wilkinson)

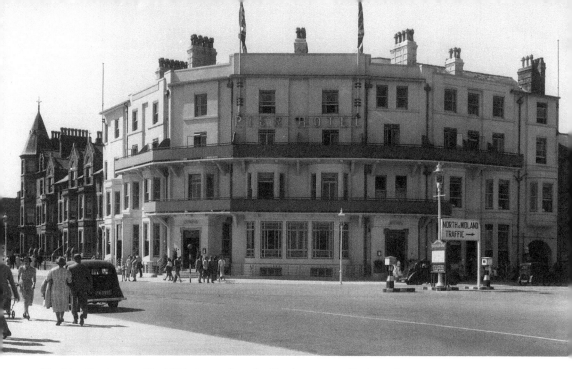

The Pier Hotel opened in 1881. It was described in the press as 'Perhaps the most imposing structure in the town'. The hotel was seriously damaged by a fire on 28 September 1963, which started around 3 a.m. A fifty-two-year-old barman died on the top floor. This postcard is dated around 1940.

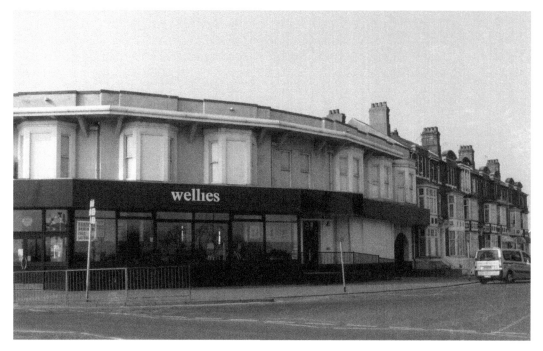

The top two floors of the hotel were removed after the fire. The former hotel, now a bar, currently trades as 'Wellies'. Prior to that it was called Barfly. (Photo by Ken Wilkinson)

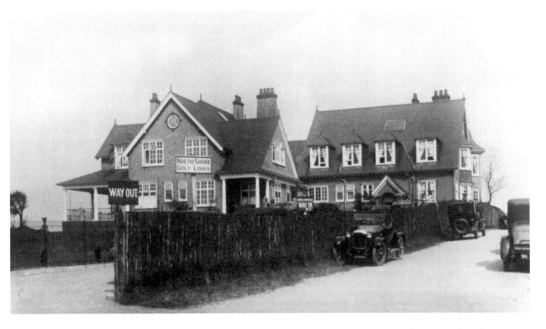

This is the clubhouse of the North Shore Golf Club in about 1930, before it became a hotel.

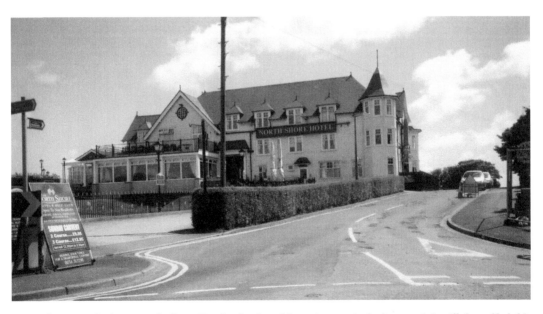

The smart-looking North Shore Hotel today has thirty-six en-suite bedrooms. It is still the golf club's headquarters and is available for wedding receptions and private functions. It is interesting to note that the streets in this area are all named after famous golf courses and called 'Drives', they are: St Andrew's Drive, Sunningdale Drive, Hoylake Drive, Muirfield Drive, and Brancaster Drive. (Photo by Ken Wilkinson)

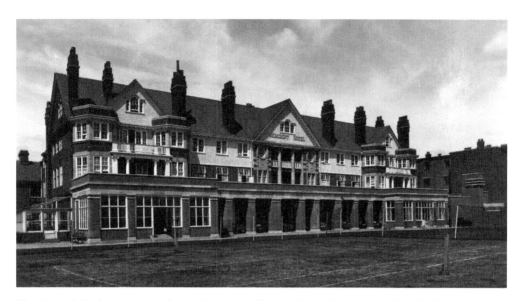

The Seacroft Hydro was opened in 1900, originally intended to be used as a health hotel using hot seawater treatments for a variety of disorders. This never caught on, but it was known as the Hydro until the 1920s, when it became the Seacroft Hotel. The main entrance is on Drummond Road, but its frontage overlooks the shore. It was taken over during the Second World War by the Royal Air force and used as their headquarters in the town, when a total of 80,000 airmen were trained in Skegness.

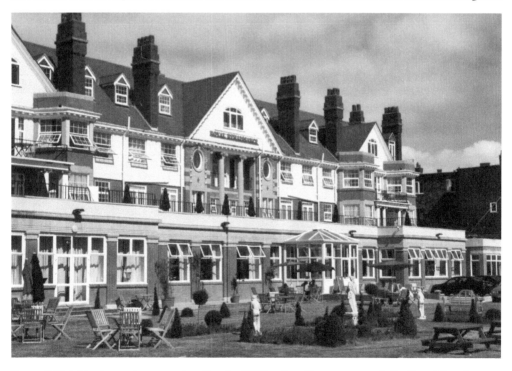

Seacroft Hotel had a major reconstruction in 2006, when it was renamed the Royal Renaissance Hotel, and, more recently, the Royal Hotel. The hotel has two restaurants, the Bollywood Indian and Viceroy's Bistro. The photograph shows the seashore frontage. (Photo by Mr C.R. Heason)

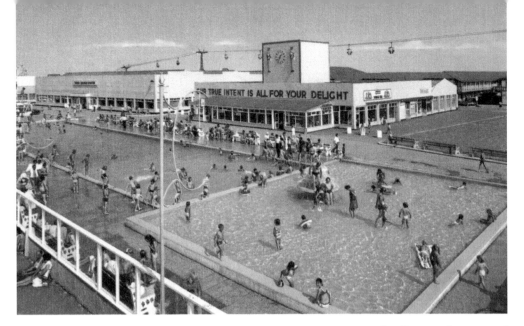

Butlin's Holiday Camp, Skegness. This was Billy Butlin's first camp. It was officially opened on 11 April 1936 by Amy Johnson, the first woman to fly solo from England to Australia. Norman Bradford, who helped construct the camp, became the very first Redcoat. The large open-air swimming pool, dining areas and other major attractions, as depicted in this 1960s John Hinde postcard, could be seen from Roman Bank (the A52). The Royal Navy took over Butlin's Camp at the outbreak of war, when it became known as HMS *Royal Arthur*. The camp was reopened on 11 May 1946, just six weeks after the Navy left.

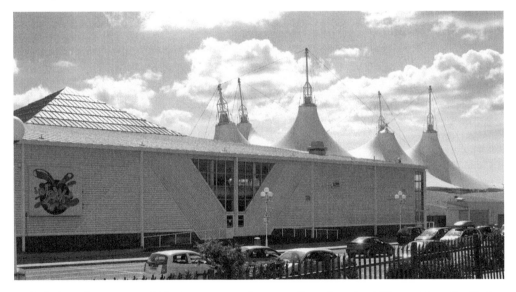

Butlin's Camp frontage now hides its attractions from travellers along the A52, apart from the Skyline Pavilion built in 1998 – a dome type structure which is a landmark visible for miles around. The Rank organisation took over Butlin's in 1972. Then, after modernisation in 1987, it became Funcoast World. The camp is now officially called Butlin's Resort Skegness and is owned by Bourne Leisure. Skegness-born Chris Barron is the Resort Director, a position he has held since 2000. (Photo by the late Winston Kime)

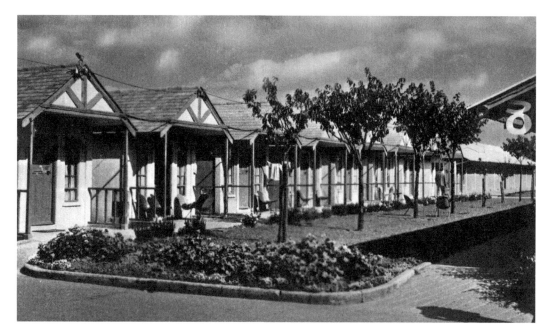

This postcard shows the original chalets at Butlin's Camp. These chalets, constructed of timber framing and cladded with cement render, without insulation, would be ideal for occasional summer use, but were not so good for the naval ratings during the war on cold winter nights.

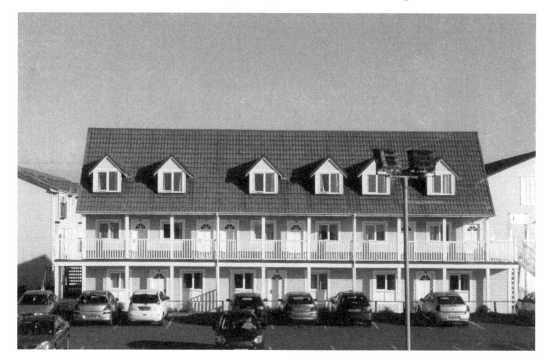

The original chalets have long gone, apart from one which was used as the head gardener's hut in 1987 – it was then fifty years old and became a grade two listed building. This photograph shows some of the more superior accommodation now offered to campers. (Photo by Ken Wilkinson)

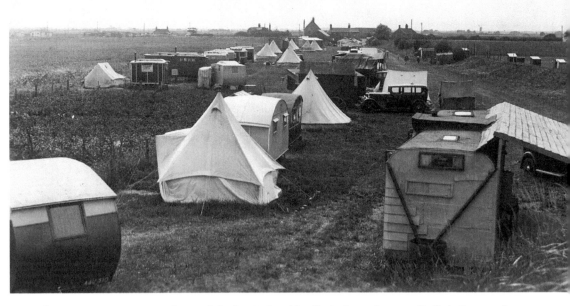

The Haven camping ground, one of the first in Ingoldmells, is situated next to Butlin's Camp and was owned by the Wilkinson family in the 1930s. Previous owners were the Mastin family, after whom Mastin's Corner was named. Note the sentry box toilets over the bank on the right.

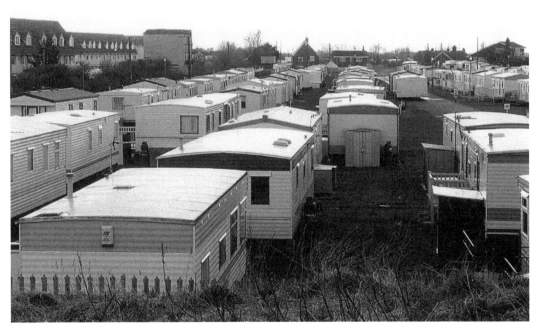

This is the same site today, owned by Laver Leisure Ltd, with caravans now more popular. On the left can be seen the accommodation blocks of Butlin's Camp. (Photo by Ken Wilkinson)

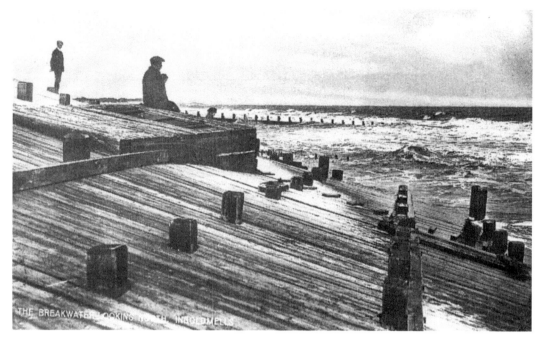

Ingoldmells Point, seen here in the 1920s, is the most easterly land on the Lincolnshire coast. This photograph shows the wooden-walled breakwater and the outfall that discharges into the sea, after gathering surface water from a network of dykes from the surrounding marshland. It was constantly silting up and large gangs of workmen were employed to dig out the sand and shingle. The problem was solved in the late 1940s by installing a pumping station.

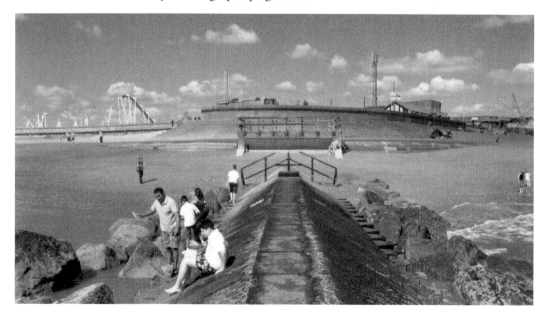

A present day view taken from the outfall. Concrete steps have replaced the previous wooden structures. The amusement rides in the distance are on the site of the Fantasy Island theme park. (Photo by David Kime)

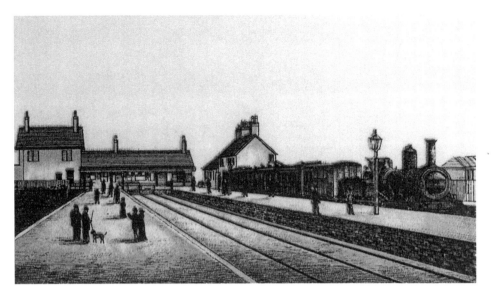

The East Lincolnshire Railway, running from Boston to Grimsby, opened in 1884, and a branch line from Firsby Junction to Wainfleet began operating in 1881. Two years later, a further extension stretched another 5 miles to Skegness. This is the railway station in its early days. The first steam train pulled into the station on 28 July 1873, when the station had four platforms with a single line to Firsby junction. Prior to this, travellers by rail would use the horse-drawn omnibus from Burgh railway station to Skegness.

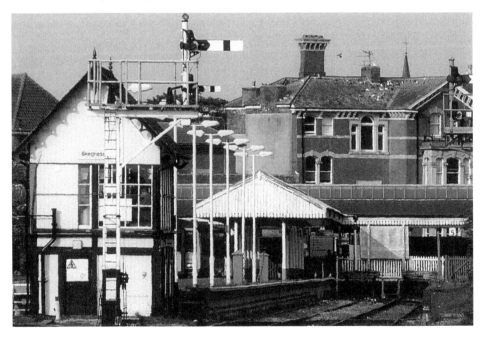

This photograph was taken with a zoom lens from the railway crossing, 250 metres from the station. The station's entrance buildings have been demolished, including the refreshment rooms and the old stationmaster's house. This makes the Lumley look more prominent. (Photo by Ken Wilkinson)

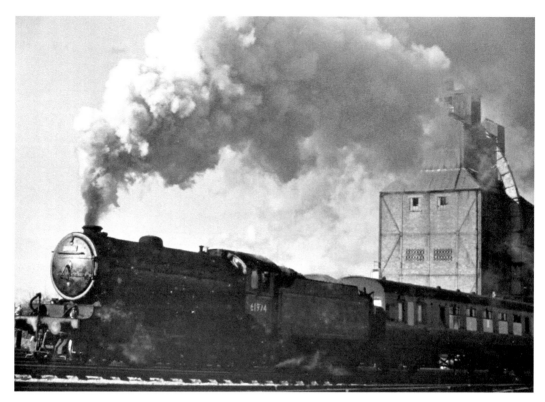

An evening train departs from Skegness in the days of steam in the 1950s. The building on the right was the retort tower of the gasworks in Albert Road. (Photo by Ken Wilkinson)

A diesel train departs from Skegness. The photograph was taken from the identical position as the one above, although the retort tower has long gone. (Photo by Ken Wilkinson)

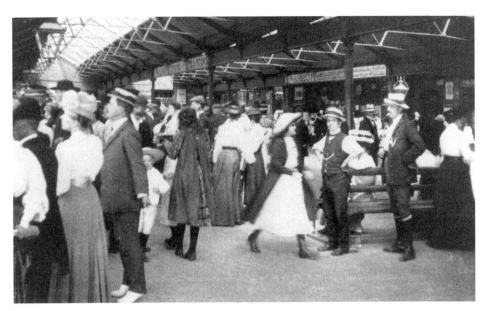

Skegness holidaymakers departing from the town's busy railway station in 1911. The advertising boards read 'Railway Dining and Tearooms' and 'G.J. Crofts Ladies and Gents Outfitters'. WH Smith had a bookstall on the station for many years. The exit to Wainfleet Road and the goods yard were to the right. The Boston to Skegness line was allowed to stay despite the 'Beeching Axe' – the government's plan to close most of the East Lincolnshire railways north of Boston in the 1960s.

The same scene today, and the station's concourse appears to have changed very little. WH Smith closed their stall in the 1960s and a small shop called Wingnuts now sells refreshments and some stationary. Extensive work is ongoing; entrance buildings, refreshment room, and the former stationmaster's house were all demolished during 2011. New entrances to both Lumley Square and Richmond Drive are being constructed. (Photo by Ken Wilkinson)

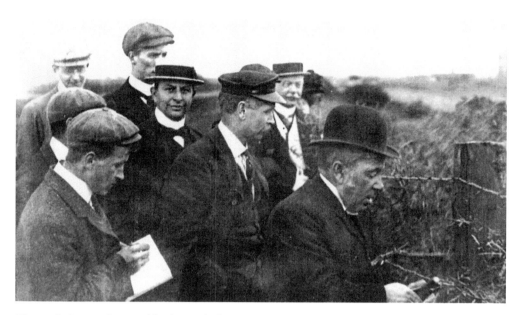

'Granny's Opening' is a public footpath that cuts across the North Shore Golf Links, from Roman Bank, Winthorpe, to the seashore. When the golf course was being constructed in 1908 the owner, solicitor Lawrence Kirk, blocked off the footpath with barbed wire. This photograph shows Samuel Moody and objectors cutting down the wire during an organised demonstration. Lawrence Kirk thereupon summoned half a dozen protesters to appear at Spilsby Sessions House, charged with trespass. The magistrate ruled that a right of way had been proved and the footpath was reopened.

Granny's Opening footpath is still open today. Onshore pipes and cables from Centrica's offshore Lynn and Inner Dowsing Wind Farm (operational since 2008) are buried under this path, and continue down Church Lane Winthorpe to the substation at Middlemarsh. (Photo by Ken Wilkinson)

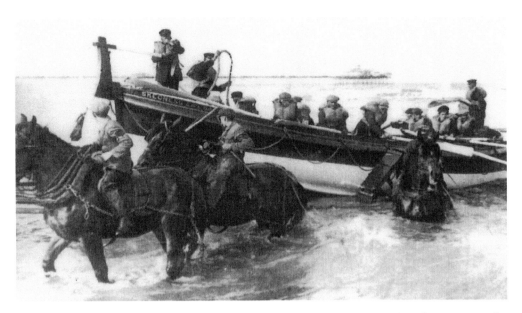

The launch of the Skegness lifeboat *Samuel Lewis* in the early 1920s. Frank Wilkinson is on the leading horse with his cousin, Henry, just behind him. The horses belonged to Mr C.F. Grantham JP, who was the Honorary Secretary from 1882 to 1922. The *Samuel Lewis* was the last of the rowing/sailing boats. It had twelve oarsmen and was in service between 1906 and 1932, when it was replaced by the motor lifeboat *Anne Allen*. Matthew Grunnill was the coxswain from 1908 to 1932.

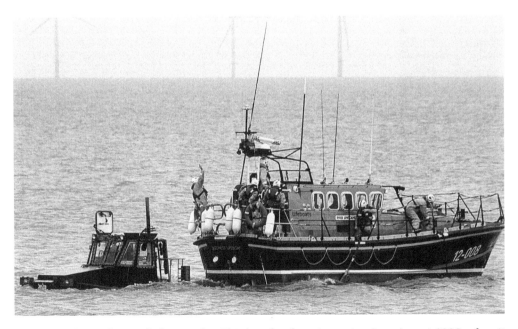

Skegness lifeboat, *The Lincolnshire Poacher*. This boat has been in service since August 1990, when it replaced the *Charles Fred Grantham*, which had been in service from April 1964. John Irvine has been the coxswain since 1 January 2000. This launch, on 20 March 2011, was to scatter the ashes of Winston Kime, co-author of this book, who died on 14 November 2010, aged 98. (Photo by David Kime)

If you enjoyed this book, you may also be interested in...

Butlin's: 75 Years of Fun!

SYLVIA ENDACOTT & SHIRLEY LEWIS

This nostalgic selection of images illustrates the history of the various camps and hotels, including all of the things we associate with this most British of establishments. From Redcoats to water worlds, and from the Glamorous Grandmothers competitions to National Talent contests, this book provides an enjoyable and nostalgic trip down memory lane for all who know and love Butlin's, allowing us a glimpse into the social history of this quintessential British holiday.

978 0 7524 5863 2

The A-Z of Curious Lincolnshire: Strange Stories of Mysteries, Crimes and Eccentrics

STEPHEN WADE

Filled with hilarious and surprising examples of folklore, eccentrics, and historical and literary events, all taken from Lincolnshire's tumultuous history, the reader will meet forgers, poets, aristocrats, politicians and some less likely residents of the county, including Spring-Heel'd Jack and the appearance of an angel in Gainsborough. This is the county that brought us Lord Tennyson, John Wesley, and notorious hangman William Marwood; here too were found the Dam Busters, the first tanks and the fishing fleets of Grimsby.

978 0 7524 6027 7

A Grim Almanac of Lincolnshire

NEIL R. STOREY

This day-by-day catalogue of 365 ghastly tales from around the county explores the darker side of Lincolnshire's past, from the twelfth to the twentieth centuries. Including diverse tales of highwaymen, smugglers, giants, hangmen, poachers, witches, rioters and rebels, and also featuring accounts of prisons, punishments, dreadful deeds, macabre deaths, strange occurrences and heinous homicides, the nasty goings-on of Lincolnshire's yesteryear are all here.

978 0 7524 5768 0

Bloody British History: Lincoln

DOUGLAS WYNN

Built by the Romans, looted by the Danes and conquered by King William I, the city of Lincoln has had a long and most dreadful history. Containing medieval child murder, vile sieges of (and escapes from) the castle, the savage repression of the Lincolnshire rising by King Henry VIII (who had the ringleaders hanged, drawn and quartered) and plagues, lepers, prisons, riots, typhoid, tanks and terrible hangings by the ton, you'll never see the city in the same way again.

978 0 7524 6289 9

Visit our website and discover thousands of other History Press books.

www.thehistorypress.co.uk